JANE ROBERTS

HOLBEIN
AND THE COURT OF
HENRY VIII

Drawings and Miniatures from The Royal Library
Windsor Castle

National Galleries of Scotland
MCMXCIII

Published 1993 by the Trustees of the
National Galleries of Scotland for the exhibition held
at the National Gallery of Scotland, Edinburgh, 23 July to 26 September 1993;
the Fitzwilliam Museum, Cambridge, 2 October 1993 to 9 January 1994; and the
National Portrait Gallery, London, 21 January to 17 April 1994.

Designed and typeset in Monotype Dante by Dalrymple
Printed by BAS Printers
Over Wallop

Front cover: detail from *Sir John Godsalve*, no. 14
Back cover: *Elizabeth, Lady Audley,* no. 30
Frontispiece: Wenceslaus Hollar after Hans Holbein the Younger (or Lucas Horenbout ?)
Hans Holbein the Younger, 1543, etching, 138 × 106 mm
Windsor Castle, Royal Library; Parthey 1418

Sponsor's Foreword

Capital House is an international investment management company, with offices in London, Edinburgh, Jersey, Guernsey, Isle of Man, Hong Kong, Boston and Singapore.

Despite opening our doors for business in 1987 against a background of world recession and dire economic conditions, we now manage approaching £4.5 billion on behalf of institutions and private individuals.

I regard this sponsorship as being of the highest international calibre, of a quality which echoes our own corporate objectives. I am especially delighted that a wide and varied public will be able to enjoy this unique and historic event, not only in the capital cities of London and Edinburgh where we ourselves operate but in Cambridge, one of the great seats of learning.

This is our first major venture into sponsorship of any kind, and I am proud that our contribution will allow so many to see, and perhaps be inspired by this wonderful selection of portrait drawings and miniatures from the Royal Collection at Windsor.

PAUL FIELD
Managing Director · Capital House Investment Management Limited

Foreword

The National Galleries of Scotland are delighted to have had the opportunity to collaborate with their colleagues at the Fitzwilliam Museum, Cambridge, and the National Portrait Gallery, London, in showing, to what we hope will be many thousands of visitors, this selection of drawings and miniatures by Hans Holbein the Younger, from The Royal Library at Windsor Castle. We are most grateful to Her Majesty The Queen for graciously allowing these magnificent treasures to be borrowed by our three galleries during this anniversary year of Holbein's death.

The exhibition could not have been organised without the co-operation of Oliver Everett, the Librarian at Windsor, Jane Roberts, Curator of the Print Room, who wrote this catalogue, and Theresa-Mary Morton, Assistant Curator, Exhibitions, at The Royal Library. It would not have taken place without the generous sponsorship offered by Capital House Investment Management Limited, to whom, with my colleagues, Simon Jervis, the Director of the Fitzwilliam Museum, and John Hayes, the Director of the National Portrait Gallery, I should like to express my thanks.

<div align="center">

TIMOTHY CLIFFORD
Director · National Galleries of Scotland

</div>

Preface

The year 1993 marks the 450th anniversary of the death of Hans Holbein in London. It is fitting that the occasion should be marked by the present exhibition of the work of this great artist from the unrivalled holding of his drawings and miniatures in the Royal Collection.

An exhibition had been planned in 1943 by the then Director of the Victoria & Albert Museum, Sir Eric Maclagan, to honour the 400th anniversary of Holbein's death, but it was decided that the time was not right and that 'the exposure of works of art of this magnitude appears unwise in the circumstances of modern war'.

An exhibition devoted to Holbein's works in the Royal Collection was held in The Queen's Gallery, Buckingham Palace, in 1978–9. Thereafter, many of the Windsor drawings were shown in America in 1982–3; a smaller selection was shown in Hamburg, Basle, Houston and Toronto in 1987–8. These drawings have not been seen in the United Kingdom since 1979.

We are doubly pleased, therefore, to be able to honour Holbein in 1993 and to enable these outstanding works of art to be enjoyed by a large number of people in the United Kingdom. It has been a pleasure to work with the National Gallery of Scotland, Edinburgh, the Fitzwilliam Museum, Cambridge, and the National Portrait Gallery, London, on this exhibition.

OLIVER EVERETT
Librarian · Windsor Castle

Acknowledgements

This publication has been completed with the help of many people in the Royal Collection Department at Windsor and St James's Palace. Thanks are also due to Dr Maryan Ainsworth (of the Metropolitan Museum of Art, New York), to Dr Susan Foister (of the National Gallery, London), to Dr Lorne Campbell (of the Courtauld Institute) and to Mr Jim Murrell (of the Victoria & Albert Museum) for their kindness and advice.

All photographs of items in the Royal Collection are reproduced by gracious permission of Her Majesty The Queen. Other comparative material has been reproduced with the kind permission of the following. The text within square brackets relates to the section or catalogue entry in the context of which the illustration is reproduced: Basel, Kupferstichkabinett der Öffentlichen Kunstsammlung [Intro. and 1]; Berlin, SMPK, Kupferstichkabinett: foto Jörg Anders [Intro. and 7]; Bowhill, Selkirk, The Duke of Buccleuch & Queensberry, KT [31]; Cambridge, Fitzwilliam Museum, by permission of the Syndics [26]; Dresden, Gemäldegalerie Alte Meister [14]; Florence, Gab. Fotografico Soprintendenza Beni Artistici e Storici [20]; Frankfurt, Städelsches Kunstinstitut [19]; London, British Library [25 and 29]; London, British Museum, Department of Prints and Drawings, by permission of the Trustees [10]; London, Sotheby & Co. [22]; New York, Frick Collection [2]; New York, Metropolitan Museum of Art [18]; New York, Metropolitan Museum of Art, Paintings Conservation Department [2, 18 and 19]; Paris, CARAN, Archives Nationales [29]; Paris, Documentation Photographique de la Réunion des Musées Nationaux [8]; Philadelphia Museum of Art, John G. Johnson Collection [14]; St Louis Art Museum [6]; São Paulo, Museu de Arte [12]; Sudeley Castle Collection [Intro.]; Vienna, Kunsthistorisches Museum [21].

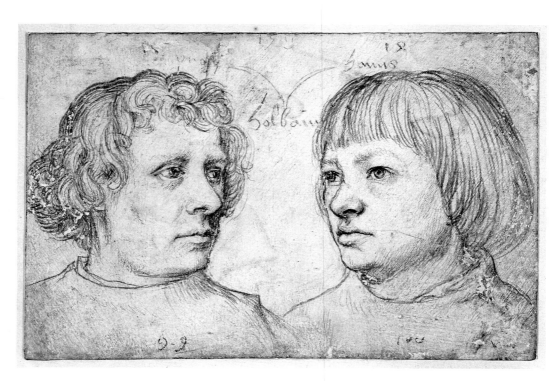

Hans Holbein the Elder *The Artist's Sons, Ambrosius and Hans the Younger*
(metalpoint on prepared paper, 103 × 155 mm; Berlin, SMPK, Kupferstichkabinett; KDZ 2507).

THE ARTIST

HANS HOLBEIN THE YOUNGER WAS BORN IN AUGSBURG, THE second son of an artist of the same name. Hans the Younger (1497/8–1543) and his brother Ambrosius were both trained by their father, developing their skills as painters, draughtsmen and designers. Augsburg was one of the first towns in southern Germany to feel the effects of the Italian Renaissance. There is a possibility that the Holbein brothers actually visited Italy, in connection with their documented visits to Lucerne in 1517 and 1519. In the meantime, they had settled in Basel. Hans joined the painters' guild there in 1519 and in the following year became chamber-master of the guild and a citizen of Basel.

Basel was a notable literary centre. Holbein provided several publishers with designs for illustrations and thereby came into contact with some of the humanists active there. He painted two portraits of Erasmus in 1523, one of which was destined for Archbishop Warham in England. He also painted a number of house façades, using sophisticated illusionistic techniques. But much of his work was of a religious nature – altarpieces, devotional panels, designs for stained glass windows – and was destroyed in the iconoclastic raids of the late 1520s. After visiting France in 1524, where he may have seen portraits (both drawn and painted) by Jean Clouet (c.1485/90–1540/1), Holbein was advised to travel north. The solicitous Erasmus provided him with introductory letters to both Pieter Gillis in Antwerp and Thomas More in London.

By December 1526 Holbein had reached England, where More appears to have acted as his chief protector, patron and adviser. More informed Erasmus of his safe arrival and added: 'Your painter is a wonderful artist, but I fear he will not find England such fruitful and fertile ground as he had hoped'. From the surviving works of art, it would appear that Holbein's main activity throughout his two sojourns in England was portrait-painting, at which he had already proved himself adept in Basel. But the group portrait of the More family (for which see nos. 1–5) was infinitely more ambitious than any composition he had undertaken before. Tragically, it was destroyed in the eighteenth century; however, its appearance is recorded in a number of copies. The survival of so many of Holbein's portraits, and the destruction of so many of his other works (decorative schemes, mural paintings, small-scale designs for metalwork, and so on), probably gives a very distorted impression of his activity in England.

'Master Hans', almost certainly identifiable as Holbein, was paid for painting in connection with the court festivities at Greenwich in 1527, all traces of which have long since disappeared. These entertainments – which celebrated the new Anglo-French alliance – were the responsibility of Sir Henry Guildford (no. 6), the King's Master of the Revels, who was portrayed by Holbein in the same year.

Between 1528 and 1532 Holbein was back in Basel with his family, for whom he purchased a large house overlooking the Rhine. With the iconoclastic movement gathering momentum, it was not surprising that very few certain works can be dated from these years. Throughout his time in England he operated as a foreigner. Soon after his return to England in 1532, he drew Mary Zouch and annotated his study (no. 27) *black felbet*, revealing a somewhat basic knowledge of the English language. He remained a citizen of Basel to the end of his life, and his family continued to reside there under the protection of the City Council.

By July 1532 the artist was in London again, although many of the friends and patrons of his first visit were no longer in a position to employ him. More and Fisher opposed the King's divorce and the break with Rome and were executed in 1535. Both Guildford and Warham died in the course of 1532. But Holbein evidently had other supporters and soon set to work on a great series of portraits – of merchants, ambassadors, courtiers and of the King himself – which punctuate the remaining eleven years of his life. The royal accounts are lost until 1537; however, Holbein was described as 'the King's painter' by the poet Nicholas Bourbon in a letter published in 1536 (but possibly written in 1535), and received regular payments towards a salary of £30 for his work as King's Painter from 1537. As such, he would have been expected to portray members of the royal family, including the King's prospective brides (whom Holbein had to record in 1538 and 1539), to devise and execute decorative schemes (such as the dynastic painting in Whitehall Palace), and to design small-scale items such as jewels, clocks, daggers and table-decorations. He also continued to supply printers with book illustrations. Whereas in almost every respect Holbein's artistic activity in England was innovatory, for another of his pursuits – the painting of miniatures (for which see nos. 29–33) – Holbein appears to have developed the necessary techniques only after his arrival in this country. But Holbein's role in the later development of miniature painting, as of most other aspects of English art, was crucial.

Apart from his employment at court, Holbein evidently maintained a private portrait-painting practice, the chief documents of which are the portraits themselves. At the time of his death (probably from the plague) in 1543, he was a resident of the Parish of St Andrew Undershaft in the City of London, significantly closer to the workshops of goldsmiths and silversmiths and to the German merchant community than to the royal court at Whitehall.

❧ THE SITTERS ❧

ALTHOUGH HOLBEIN'S ACTIVITY AS A PORTRAIT PAINTER WAS only one aspect of his artistic production, it is that for which he is best known today. The lack of sitters' books, accounts and early records means that our knowledge of Holbein's English clientele is derived from the identifications attached to his painted and drawn portraits. In most cases these identifications are dependent entirely on the inscriptions applied to the Windsor drawings.

As we will see, the earliest certain reference (dated 1590) to the 'great booke' containing these drawings, describes the sitters as 'certyne Lordes, Ladyes, gentlemen and gentlewomen in King Henry the 8: his tyme, their names subscribed by Sr John Cheke Secretary to King Edward the 6'. Cheke had served as tutor to Prince Edward from 1542, and could therefore have known both Holbein and many of those whom he portrayed. Sixty-nine of the eighty-five drawings (eighty of which are autograph) at Windsor bear identifications. The majority of the unidentified drawings can be placed securely in Holbein's early years in England (e.g. nos. 3, 5 and 7): the sitters may therefore have been unknown to Cheke. The sitters in other unidentified drawings, from the 1530s (e.g. nos. 17 and 18), may conceivably have been foreigners, portrayed during a visit to England.

It is unlikely that any of the identifying inscriptions borne by the drawings today are either in Cheke's hand or of sixteenth-century date. The present inscriptions were probably copied, in the early eighteenth century, from those that Cheke had placed below the drawings in the great book. They are in two styles: more commonly a regular disjointed script in gold over red, occasionally (e.g. nos. 15, 19 and 24) a more cursive style. The fact that a cursive inscription has been deleted and a regular one applied, in nos. 13 and 14, suggests that the cursive preceded the regular style. We cannot judge how accurately Cheke's inscriptions were copied, or whether errors (such as Thomas for Henry, in no. 12) were introduced by the copyist.

With the possible exception of no. 7, all the Windsor drawings were made in England, probably in London. On Holbein's arrival there in 1526, it was only natural that he should turn to the friends and correspondents of his own patron, Erasmus: principally Thomas More (no. 2), but also Guildford, Warham and Fisher (nos. 6, 8 and 9). Each of these men also held key public positions, whether secular or ecclesiastical. Holbein was soon introduced into royal circles, and by 1527 was being paid for historical paintings for the King.

Very little is known about Holbein's role as a portraitist within the context of his position

as King's Painter. The salary that he received from the King (£30 a year) would certainly have needed to be supplemented. Jean Clouet, who held a similar position at the French court, appears to have portrayed members of the family and court of François I almost exclusively. While some of Clouet's portraits were destined for 'reduction' as miniature illuminations in manuscripts produced for the King, others were translated into independent panel paintings (of courtiers and apparently for court use) of the same scale as the drawings (see Mellen, *passim*). However, Holbein is known to have had strong links with the German merchant community in London and his painting practice appears to have retained a certain independence. Like Holbein, Clouet was a foreigner at court.

Holbein's first royal portraits probably date from around ten years after his first work for Henry VIII: the drawing of Jane Seymour (no. 21) is related to both the Whitehall mural of 1537 (destroyed in the fire of 1698, but known from copies: see illustration below) and to the contemporary independent panel paintings. No drawing of Henry VIII has survived. A portrait of Jane and Henry's son, the future Edward VI, was made in 1538–9; there is a preparatory drawing at Windsor (Parker 46).

The majority of Holbein's sitters held positions at court. Some were the 'new men' promoted by Thomas Cromwell: men such as Godsalve (no. 14) or Southwell (no. 20) who came from Norfolk to assist with the reforms that followed the King's divorce and break with Rome. Southwell, a convicted murderer, betrayed both More and his childhood friend, Henry Howard, and was knighted in 1540. Others portrayed by the artist were of a more scholarly persuasion: both Sir Thomas and Lady Elyot (nos. 10 and 11) were associated with More's family 'academy': Elyot's *Boke named the Governor* (1531) was a notable statement of humanist ideals. Henry Howard, Earl of Surrey (no. 12), introduced blank verse into the English language and was a notable scholar and poet; but Sir Thomas Wyatt (no. 25) was acknowledged as the outstanding poet of his age.

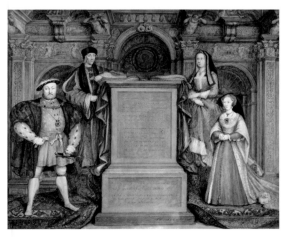

left to right

George Vertue (1737) after Remigius van Leemput (1667) after Holbein (1537) *Henry VII, Elizabeth of York, Henry VIII and Jane Seymour* (watercolour, bodycolour and pen and ink, 457 × 573 mm; Windsor Castle, Royal Library; RL 13581).

Hans Holbein the Younger *Thomas Howard, 3rd Duke of Norfolk* (oil on panel, 80.6 × 60.9 cm; Royal Collection; Millar 30, Rowlands 68).

Hans Holbein the Younger *Sir Henry Guildford* (no. 6; 383 × 294 mm).

Hans Holbein the Younger *Lady Guildford* (chalk, 552 × 385 mm; Basel, Kupferstichkabinett der Öffentlichen Kunstsammlung; 1662.35).

In various instances, Holbein portrayed several members of the same family. Thomas Howard, 3rd Duke of Norfolk, was a particularly important patron: although no drawing of the Duke has survived, there is an oil painting datable 1538–9 in the Royal Collection (Millar 30; Rowlands 68). The Duke's daughter, Mary, his son, Henry (no. 12), and his daughter-in-law, Frances (no. 13), were all probably drawn a few years earlier, c.1532. More portraits of Henry Howard survive by Holbein than of any other English sitter.

The frontal stance of most of the Howard portraits suggests that they might have been conceived as a series. It is self-evident that the portraits of the Elyots (nos. 10 and 11) are a pair. Other drawings may have been lost, or (as with no. 6: see illustrations below) have become detached from their partner. The miniature portraits of the Brandon boys, painted in 1541, work as a pair but may not have been conceived as such. The portraits of members of the More family (nos. 1–5) were made in preparation for a group portrait.

Because of the exclusively metropolitan nature of Holbein's painting practice, it comes as some surprise that two of his sitters – William Reskimer (no. 16) and Simon George (no. 19) – were based far to the west, in Cornwall. Although Reskimer is now known to have been living in Middlesex at the end of his life, no court – or London – connection has yet been found for Simon George.

It is unlikely that many of those portrayed by Holbein would have sat to another artist – unless they travelled on the continent. Holbein's arrival in England presented them with an opportunity for portraiture which had not presented itself before, and which would not occur again for many years. It is no exaggeration to state that our vision of the court of Henry VIII is dependent on Holbein's images. For the truthfulness of these images we must depend on the judgement of one of his sitters, Nicholas Bourbon: 'O stranger, if you desire to see pictures with all the appearance of life, Look on these which Holbein's hand has created'.

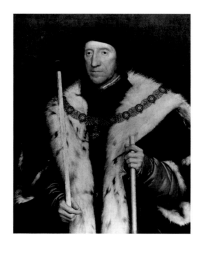
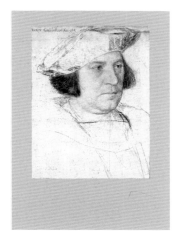
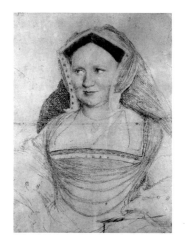

THE DRAWINGS

Technique & Function

IT HAS LONG BEEN RECOGNISED THAT THE DRAWINGS RESULTING from Holbein's two visits to England can be distinguished from each other on technical grounds. Those from the first visit (1526–8) are drawn in black, white and coloured chalks on plain paper, while those from the second visit (1532–43) use paper with a pink priming, on which the artist has delineated the forms in a combination of chalk, ink (applied with pen or brush) and metalpoint. And the drawings from the second visit are in general on a smaller scale than those from the first. However, it would be wrong to see this as a logical development or progression, for Holbein had used a coloured priming, combined with metalpoint and coloured chalks, long before his first visit to England. His use of unprimed paper between 1525 and 1528 was almost certainly the result of direct contact, during the visit to France in 1524, with the portrait drawings in a similar medium by Jean Clouet. A comparison of the two studies of Jakob Meyer zum Hasen in Basel shows clearly the changes thus effected: the first portrait, of 1516, is in metalpoint and coloured chalks on a light blue preparation; the second, of 1526, is in coloured chalks on an unprepared paper. There has also been an increase in scale: from 281 × 190 mm to 383 × 275 mm.

Most of Holbein's portrait drawings include coloured chalks. This is often applied with such subtlety that it is overlooked. The first surviving drawing in this medium appears to be Fouquet's study for his portrait of *Jouvenel des Ursins* of *c.*1455 in Berlin (Mellen, Figure 5). Knowledge of the technique may have passed, via Perréal, to both Clouet and Leonardo da Vinci, and thence to Holbein. A technical sophistication which can be observed in Holbein's work, particularly in the Windsor drawings, is the working of the chalks, either by wet or dry methods, to create an effect similar to watercolour. This can be seen particularly in the flesh tints of drawings such as nos. 3–8, but is also discernible in the drawings on a pink ground. In the latter, highlights – still sparkling, after around four hundred and fifty years – were applied in liquid white (e.g. nos. 10, 11, 13, 14, 15, 17 and 24).

The drawings from Holbein's second English visit occasionally contain crude line-work, in metalpoint or pen and ink, which has given rise to heated debate concerning studio intervention, subsequent reworking, and so on. Indeed, Ganz considered that all the penwork was later, a view which is manifestly untenable in the context of drawings such as nos. 17 and 24,

where the same hand was clearly responsible for both the notations (of colour and material) and the ink lines on the drawing. There is no reason to doubt that these annotations (in German) were made by Holbein.

Recently the detailed technical studies of Holbein's oil paintings, brilliantly summarised by Maryan Ainsworth, have shown how – by the 1530s at any rate – the media employed in the drawings were directly related to the use of these drawings as 'patterns'. The subject's likeness would be recorded by Holbein from the life, using a combination of coloured chalks and ink. The essential outlines of the drawing would then be transferred to panel, to be worked up into a finished picture. The transfer would be effected either by pricking (and blowing black chalk dust on to the panel behind through the pricked holes on the drawn sheet, or on an intermediary sheet: see Ainsworth, pp.176–7), or by tracing.

The latter process appears to have been that most commonly used by Holbein. The drawing would thus have been placed over an intermediary sheet of paper, its verso covered with black chalk (to produce an effect similar to modern carbon paper), and these two sheets would be laid on to the prepared panel. The outlines already established on the drawing would then have been traced over with a sharp instrument, and the outline transferred (via offsetting from the intermediary sheet) on to the panel. The tracing instrument was probably a metalpoint, or a sharp black chalk. It is indicated in the following catalogue entries as 'metalpoint over-drawing'. By making an actual size photostat of the drawings on mylar, and laying these copies over the related oil paintings – and where possible a photographic print of the under-drawing (made from an infra-red reflectogram assembly) – it has been shown that the sharp metalpoint lines in drawings such as no. 18 are precisely reproduced in the (traced) chalk under-drawing on the panel. It can also be suggested that the pen and ink contours on no. 19 were added to reinforce the outlines, after the tracing process had partially destroyed the drawn lines immediately below.

This tracing process, used by many early sixteenth-century artists (including Clouet), and later described by both Vasari and Armenini, was apparently perfected by Holbein in the 1530s and 1540s when his portrait painting practice was at its peak. Whereas the drawings of the 1520s contain very detailed chalk work, the later studies – particularly some of those excluded from the present selection – show a decrease in plasticity, a simplification of form, and a greater concentration on expression: the bare essentials, which could now easily be transferred to panel. Once the process had been perfected, the painting of the portrait could even be entrusted to an assistant – as it evidently was in the case of no. 18 and for the secondary versions of no. 21. We can only guess at the composition of Holbein's workshop or studio: as a foreigner, he would not have been permitted to employ assistants, but he must have

depended on the help of others for the preparation of paints, paper and panels, and – particularly later – for the completion of his commissions. As we will see, the early history of the Windsor drawings suggests that they entered the Royal Collection at around the time of Holbein's death, and would therefore have been unavailable to copyists or posthumous followers.

A small insight into Holbein's working procedures is available in the case of one of his royal commissions. After the tragic death of Jane Seymour, Holbein was sent to the Continent to record the likenesses of certain suitable (Protestant) ladies who might be acceptable to the King. In March 1538 the artist was in Brussels to portray Christina of Denmark, the recently widowed Duchess of Milan. He was granted a sitting of three hours length, at which he presumably made a drawing. The English representative reported that the likeness was 'very perffight', and it was immediately sent to the King. The full-length painting (Rowlands 66) would almost certainly have been painted in England, on the basis of the drawn likeness made in Brussels. But having established this relationship between drawing and painting, we must acknowledge that under twenty of the Windsor drawings can be related to existing painted portraits, and only around twelve of these are autograph paintings by Holbein himself. Of the present selection, relationships exist for eleven independent drawings (nos. 2, 6, 8, 16, 18, 19, 20, 21, 22, 23 and 26) in addition to the four drawings for the More family group (nos. 1, 3, 4 and 5), that is, for fifteen out of twenty-eight images. The preparatory study for the miniature portrait of Lady Audley (no. 30) is at Windsor but is not included in this selection.

Among this great series of drawings, the portrait of Sir John Godsalve (no. 14) is something of an oddity, because of the high degree of finish applied throughout the half-length figure. The right hand supported on an illusionistic ledge at the bottom of the page is also a notable detail, in a series in which hands are very rarely included. It is possible that no. 14 was destined to become a 'paper on panel' portrait of a type found surprisingly frequently in Holbein's *œuvre*, from Benedict von Hertenstein in 1514 (Rowlands 6), to Erasmus in *c*.1523 (Rowlands 16), the artist's wife and children in 1528 (Rowlands 32) and Anne of Cleves in 1539 (Rowlands 67). In each case the drawing, on paper – or vellum in the latter instance – has been pasted on to a panel and painted over. Although considerably less highly-worked, it is possible that no. 15 was intended for the same fate.

The Paper

Our knowledge of the paper used by artists is very fragmentary, and is largely dependent on a study of watermark types. The remounting of all the drawings by Holbein in the Royal Collection, undertaken during the late 1970s, provided a unique opportunity for examination of the paper. The terms of reference used in watermark studies are still largely dependent on the published compilations of scholars working – often many years ago – in national and local archives. The references to the largest such compilation, by Briquet, in this catalogue are intended as a basic point of departure: Holbein's watermarks occasionally differ markedly from the models illustrated by Briquet.

With one exception, the drawings in this exhibition appear to have been drawn on paper produced in various paper mills in northern Europe (particularly north-eastern France), during the first three decades of the sixteenth century. The exception is no. 27, which uses paper bearing the coat of arms of the city of Zürich, where the paper itself presumably originated. Of the twenty-eight drawings included in this catalogue, fifteen carry watermarks. Among these, eight different watermark types can be identified. The most frequently used type is the two-handled vase with double flower cresting (Briquet 12863), which occurs five times (nos. 1, 5, 15, 17 and 26) among drawings from Holbein's two English visits; this paper was thus in use over a ten-year period at least. The next most frequently found watermark type is the Arms of France (Briquet 1827), which appears on three drawings all from the artist's first English period (1526–8: nos. 2, 6 and 8). Two drawings (nos. 13, 20) use a large crowned double-headed eagle type (Briquet 1427). There are single examples of the five remaining types: Briquet 878 (no. 27), Briquet 1050 (no. 10), Briquet 1255 (no. 19), Briquet 11341/2 (no. 9) and Briquet 11369 (no. 23). (Line drawings of these types were included in the 1987–8 exhibition catalogue; photographs of the watermarks are on file at Windsor.) From the available information concerning Holbein's drawings in other collections (particularly Basel), it appears that the artist used a quite different paper stock while working on the Continent.

English paper-making was still in its infancy in the early sixteenth century. For paper of a sufficiently high quality Holbein probably had to use imported stock. However, he was evidently in touch with paper-makers in London. One Lewis Demoron (possibly a Frenchman), a 'moulder of paper', was responsible for transporting his canvas of the Battle of Thérouanne from London to Greenwich in April 1527 (*Henry VIII*, p.59).

History of the Drawings

Because of their principal *raison d'être* – as patterns to be used in panel paintings – it is perhaps not surprising that all eighty or so of the drawings by Holbein in the Royal Collection were kept in an album until the early eighteenth century.

'A booke of paternes for phisioneamyes' was noted in an inventory of 1547, taken at the accession of King Edward VI. In 1590 the inventory of the possessions of John, Lord Lumley, included (among the oil paintings) *'a great booke of Pictures doone by Haunce Holbyn of certyne Lordes, Ladyes, gentlemen and gentlewomen in King Henry the 8: his tyme, their names subscribed by Sr John Cheke Secretary to King Edward the 6 wch booke was King Edward the 6'*. The 'great booke' is certainly identifiable with the volume containing the Windsor Holbeins. From the above references it is clear that the drawings belonged to Edward VI (who had sat to the artist several times) and very probable that the young King (who was only nine years old at the time of his accession) inherited them from his father. The reference in Henry VIII's inventory of 1542 to a book of patterns could possibly be associated with the great book, but it is more likely that the book passed into royal ownership following Holbein's sudden death in the following year.

Lord Lumley had acquired the Holbein drawings on the death (in 1580) of his father-in-law, Henry FitzAlan, 12th Earl of Arundel. Arundel had served as Edward VI's Lord Chamberlain and may have received the drawings at around the time of the King's death in 1553. On Lumley's own death (in 1609) his books – and drawings – passed to Henry, Prince of Wales (elder son of James VI & I). Three years later the Prince himself died, and his property was inherited by his younger brother Charles, the future King Charles I.

The next stage in the complex history of the Windsor Holbeins is documented in Van der Dort's inventory of Charles I's collection, with reference to Raphael's painting of St George and the Dragon (now in Washington): *'Item a little St Georg, wch yor Matie had in Exchange of my Lord Chamberlaine for the booke of Holbins drawings wherein manie heads were done wth Cryons wch my Lo: Chamberlaine imediatly soe soone as hee received it of yor Matie gave it to my Lo: Marshall'*. The King's exchange can be dated *c.*1627–8. The recipient of the Holbeins was Philip, 4th Earl of Pembroke, who served as Lord Chamberlain from 1626 to 1641; he evidently quickly passed the drawings on to his brother-in-law, Thomas Howard, Earl of Arundel, the Earl Marshal. Arundel formed an extensive collection of paintings and drawings during the 1620s and 1630s. This included a large number of works by Holbein, who had portrayed several of Arundel's Howard antecedents (e.g. nos. 12 and 13). Arundel's memorial allegory includes two – possibly three – identifiable works by Holbein in the foreground, in addition to a large book with tantalisingly blank pages.

The great book was described in English treatises on painting from *c*.1630. In Alexander Browne's *Appendix to the Art of Painting in Miniature* (London, 1675) it is stated that 'The Book has long been a Wanderer, but is now happily fallen into the King's Collection'. The return of the Windsor Holbeins to royal ownership, presumably during the reign of Charles II, is otherwise undocumented. Soon after the accession of George II in June 1727 his consort, Caroline, found the great book abandoned in a bureau at Kensington Palace. She thereupon arranged for the drawings to be removed from the volume and to be framed individually. At first they were hung in the new royal residence at Richmond, New Park Lodge (now called White Lodge), but they were soon transferred to the Queen's Closet at Kensington Palace, where they were stacked four-deep above miniatures (including no. 29) and other small pictures. The arrangement is the subject of one of the earliest series of hanging plans to have come down to us, made by Vertue in 1743 and published in 1758.

Vertue recorded the contents of the Queen's Closet in extraordinary detail. In addition to listing artist and subject and noting the arrangement of pictures, he made tracings (using oiled paper) of each of the Holbein drawings. On the evidence of these tracings (which survive at Sudeley Castle) it appears that the Windsor drawings had already acquired their present dimensions by the mid-eighteenth century. At some stage during the preceding two hundred years they had been severely trimmed: whereas the drawing of Sir Henry Guildford (no. 6)

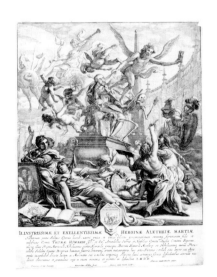

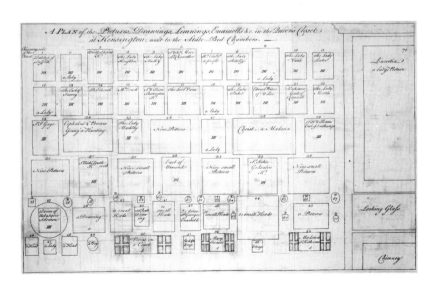

Wenceslaus Hollar after Cornelius Schut
The apotheosis of Thomas Howard, Earl of Arundel
(etching, 378 × 313 mm; Windsor Castle, Royal
Library; Parthey 466).

Hanging plan of a wall of the Queen's Closet, Kensington Palace
(engraving; from W. Bathoe, *A Catalogue of the Pictures and
Drawings in the Closet of the late Queen Caroline*, London, 1758; after
G. Vertue, 1743).

measures 383 × 294 mm, that of his wife measures 552 × 385 mm. (The illustrations of these drawings on p.15 are to scale.)

Lady Guildford, along with three other drawings from the same period (all of which are now at Basel) may never have been part of the Holbein series from the great book. However, the eight drawings by Holbein of English sitters, now scattered throughout the Print Rooms of Europe and America, may have been detached from the Windsor series during the 'travels' of the great book in the early and mid-seventeenth century. They too have been trimmed, and a small group of them have been silhouetted (Foister, figs 4–11).

By 1774 the main ('Windsor') series of drawings had returned (without their frames) to the relative safety of the guard papers of a volume – or rather two volumes – in the new Royal Library at Buckingham House. After George IV's gift of his father's library to the nation, the Holbein volumes would have moved to Windsor, with the remaining contents of the Royal Library, during the 1830s. In the following decades the drawings were finally extracted from their bindings and placed in card mounts, on the instructions of Prince Albert. Remounting operations were carried out in 1915–16 and in 1977–8, as a result of which the drawings are now freed of old glue and backing paper, and encapsulated between two thin sheets of acrylic set into an acid-free double-sided mount.

Thus protected, the drawings can not only be exhibited to a wider public, but they can also be handled and reproduced photographically with considerably less risk than previously. Soon after the completion of the most recent mounting operation, a series of full colour actual size reproductions was produced (at the Curwen Press) and published (by the Johnson Reprint Corporation in New York), with an accompanying scholarly text by Susan Foister.

Wenceslaus Hollar
after Hans Holbein the Younger
Margaret Giggs
(etching, 72 × 50 mm; Windsor Castle,
Royal Library; Parthey 1552,
after Parker 8).

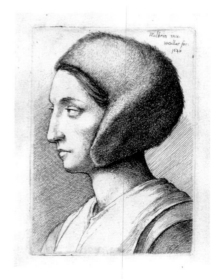

These reproductions are only the most recent in a series of publication campaigns involving the Holbein drawings, dating back to the seventeenth century when they were part of the collection of Thomas Howard, Earl of Arundel.

The drawings were among a selection of Arundel's artefacts which were copied, in small-scale etchings, by one of Arundel's reproductive artists, Wenceslaus Hollar. Around a hundred years later, George Vertue planned to produce a complete series of actual size engravings after the drawings. His tracings of thirty-four of the drawings were envisaged as part of the preparatory process for this scheme, which was never brought to completion. (The oil stains on several of the drawings, including nos. 6 and 10, were probably the direct result of Vertue's activity.) However, in the 1790s the Royal Librarian, John Chamberlaine, published a series of large-scale engraved reproductions of the drawings made by Francesco Bartolozzi. Although they were carefully printed (in colour, *à la poupée*), they are not entirely faithful to the originals. A much higher standard was achieved in the series produced earlier this century, under the directions of another Royal Librarian, Sir John Fortescue. The project, which originated at the end of Edward VII's reign, resulted in an edition of one thousand of each of eighty-three Holbein drawings, reproduced in collotype by a firm of London printers, Emery Walker, and published (on behalf of the Royal Library) by J. Manley, Printseller, of Windsor.

The various uses – and abuses – to which the drawings have been put over the past four hundred and fifty years can scarcely have enhanced their appearance, and has indeed left some of the drawings very badly abraded. The foregoing paragraphs have traced a remarkable tale of survival, in which these fragile documents of Holbein's skill as a portrait draughtsman have repeatedly overcome the destructive power of the passage of time.

right
George Vertue
after Hans Holbein the Younger
Sir Thomas More
(coloured chalks on oiled paper,
350 × 225 mm; Sudeley Castle Collection,
Winchcombe, Gloucestershire).

far right
Francesco Bartolozzi
after Hans Holbein the Younger
Cecily Heron (engraving, 388 × 276 mm;
from J. Chamberlaine, *Imitations of
Original Drawings
by Hans Holbein ... for the Portraits of
Illustrious Persons of the Court
of Henry VIII*, London, 1792–1800).

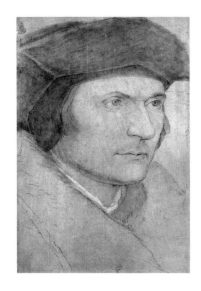 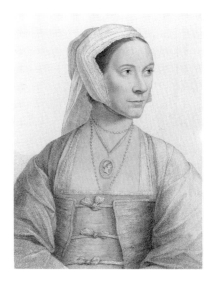

CATALOGUE
OF THE DRAWINGS

Sir John More c.1451–1530
c.1527–8

Black and coloured chalks. Inscribed in gold over red: *Iudge More Sʳ Tho: Mores Father.*
351 × 273 mm. Watermark: two-handled vase with double flower cresting (Briquet 12863).
Parker 1; RL 12224.

Sir John More was the father of Holbein's first English patron, Sir Thomas More. His own father, William, was a baker. In 1474 Sir John married Agnes Grainger, the daughter of a prosperous London citizen. Thomas was the second of the couple's six children, and the eldest son. John More gradually rose through the legal profession, becoming a barrister, Sergeant at Law (1503) and Judge of the Court of Common Pleas (1518) and of the King's Bench (1523). It is not known when he was knighted. He spent his last years in Thomas's house at Chelsea. Sir John was described by Harpsfield, one of Thomas's first biographers, as a 'man very virtuous, and of a very upright and sincere conscience … a companionable, a merry and pleasantly conceited man'.

This drawing and the four following are closely associated with Holbein's large-scale group portrait of Sir Thomas More and his family, the chief work of the artist's first English visit (1526–8; Rowlands L.10). Although the painted portrait has not survived (it is thought to have been burnt in the fire at Kremsier Castle in 1752), its appearance is known from a number of copies. One of these is the outline sketch which Holbein sent to his friend Erasmus in 1528. It shows Sir John seated in judge's robes (rather than the fur-collared gown worn here) to the right of Sir Thomas. Holbein's drawing of Sir John is one of the most sensitive portrayals of a septuagenarian ever made.

Hans Holbein the Younger *The Family of Sir Thomas More*
(pen and ink, 388 × 524 mm; Basel, Kupferstichkabinett der Öffentlichen Kunstsammlung; 1662.31).

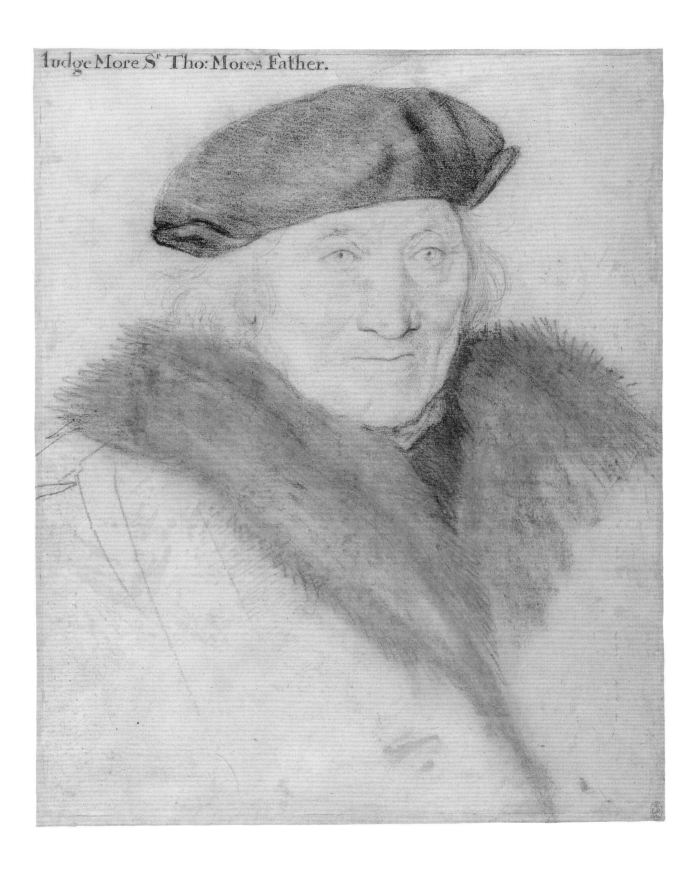

Iudge More S.^r Tho: Mores Father.

Sir Thomas More 1477/8–1535
c.1527–8

Black and coloured chalks, the outlines pricked for transfer. Inscribed in gold over red: *Tho: Moor L^d Chancelour*.
397 × 299 mm. Watermark: crowned shield containing three fleurs-de-lys (Arms of France; Briquet 1827).
Parker 3; RL 12268.

Sir Thomas More was a crucial figure, both in public life and among the English humanists, for around thirty years until his execution in 1535. For Holbein he was particularly important, as the recipient of a letter of introduction written for the artist by Erasmus in 1526. More was a close friend and correspondent of Erasmus from the 1490s. Erasmus's satire, the *Moriæ Encomium*, was written in More's London house in 1509, while More's *Utopia* was published, in 1516, with Erasmus's assistance. It is assumed that the artist stayed with More throughout his first visit to England 1526–8, when his chief work was the portrait of More's family. There he is shown with his father (no. 1), his children (nos. 3 and 4) by his first marriage (to Jane Colt, who died in 1511), his second wife Alice, and members of their household (no. 5).

More was educated in the household of John Morton (Archbishop of Canterbury) and at Oxford (c.1492–4). Like his father, his first profession was as a lawyer, and in 1529 he succeeded Wolsey as Lord Chancellor. He was also active in the world of politics and diplomacy: he entered parliament in 1504, visited Flanders in 1515, joined the King's Council in 1517 and became Speaker in the House of Commons in 1523. But throughout his life More retained a profound religious devotion and asceticism. In the later 1520s and early 1530s he became increasingly concerned about the King's planned divorce and the proposed break with Rome, and in 1532 he resigned as Lord Chancellor on the grounds of ill-health. More was committed to the Tower in April 1534, was charged with treason and condemned to death. On 6 July 1535 he was beheaded, having proclaimed that he was 'the King's good servant, but God's first'. He was beatified in 1886 and canonised in 1935.

Although this drawing is associated with More's appearance in the lost group portrait, it is probably more directly related to Holbein's half-length painting dated 1527 (New York, Frick Collection; Rowlands 24). However, the contours in that painting, though close, are not identical to those in no. 2, and the dots still visible (by infra-red reflectography) beneath the painted surface do not correspond to the pricked lines of the Windsor drawing (Ainsworth, pp. 176–7). A second drawing at Windsor (Parker 2) is rather closer to More's appearance in the group portrait. A third (pricked) drawing of More by Holbein must have served as the cartoon for the Frick painting.

far left
Hans Holbein the Younger
Sir Thomas More, 1527
(oil on panel, 74.2 × 59 cm; New York,
© The Frick Collection; Rowlands 24).

left
Infra-red reflectogram assembly:
detail of the face in Holbein's portrait of
Sir Thomas More (New York, The Frick
Collection; photograph reproduced by
courtesy of the Paintings Conservation
Department, Metropolitan Museum
of Art).

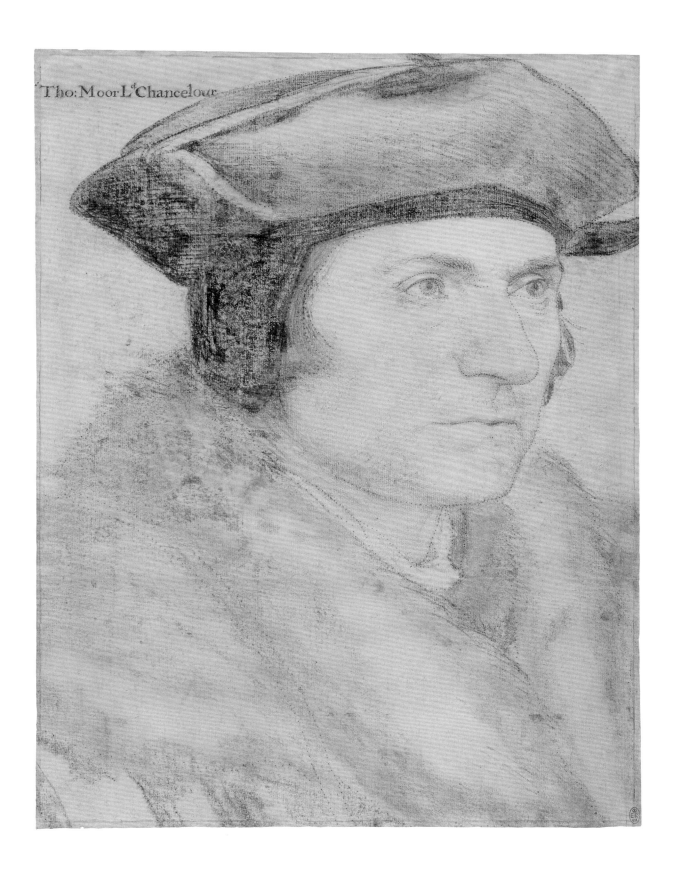
Tho: Moor Lᵈ Chancelour

Cicely Heron b.1507

c.1527–8

Black and coloured chalks. 378 × 281 mm.
Parker 5; RL 12269.

Cicely Heron was More's third and youngest daughter. With her brother and sisters she was educated at home, first at Bucklesbury and later at Chelsea. Erasmus described the More family establishment as Plato's Academy in a Christian shape. Scripture was read aloud at meal-times, and each of the children learnt Latin, Greek, logic, philosophy, theology, mathematics, astronomy and music, their progress in each subject carefully supervised by their father.

On the same day (29 September) in 1525 as More took up his appointment as Chancellor of the Duchy of Lancaster, his second daughter (Elizabeth) married William Dauncey and his younger daughter (Cicely) married Giles Heron, one of More's wards. In More's last letter, written – on the eve of his execution – to his eldest daughter, Margaret, he requested: 'Recommend me when ye may to my good daughter Cicely, whom I beseech our Lord to comfort. And I send her my blessing, and to all her children, and pray her to pray for me. I send her a handkerchief: and God comfort my good son her husband'. In Holbein's group portrait, for which this drawing is preparatory, Cicely sits – or possibly kneels – at her father's feet, wearing (as here) an ingenious expanding bodice, which could be adjusted to suit her expectant state. Her undergarment and square neckline, coloured yellow in the drawing, are shown as gold in the painted copies. The similarity of Cicely's pose to that of Cecilia Gallerani, as portrayed by Leonardo da Vinci, has often been remarked upon.

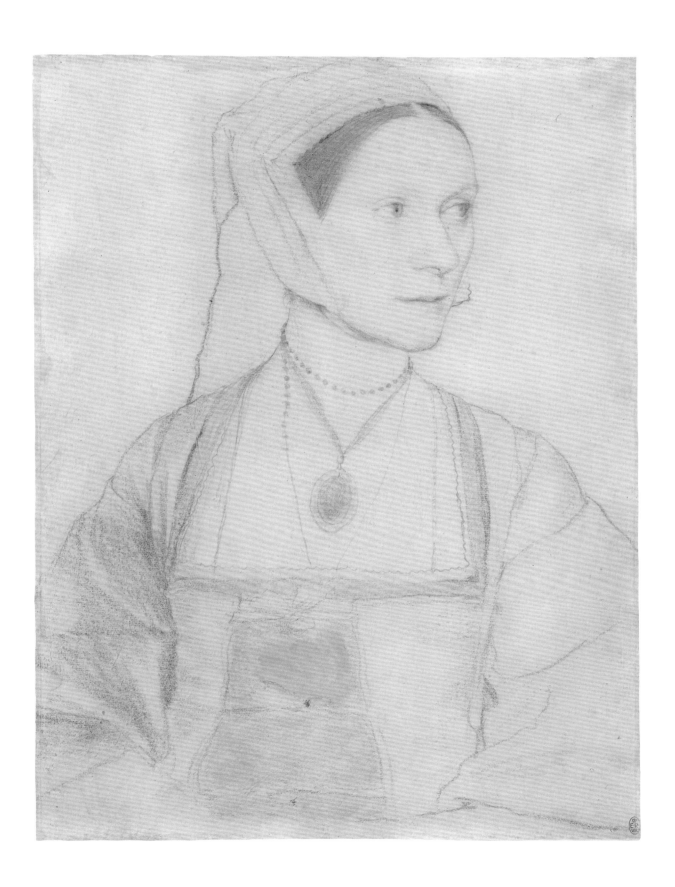

John More the Younger c.1509–47

c.1527–8

Black and coloured chalks.
Annotated by the artist, in black chalk: *lipfarb brun* (brown complexion).
Inscribed in gold over red: *Iohn More Sr Thomas Mores Son.*
381 × 281 mm. Parker 6; RL 12226.

John More was Sir Thomas's fourth child and only son. In 1527, the time of Holbein's visit to England, he became betrothed to his father's ward, Anne Cresacre (no. 5); they married two years later. John was educated at home, with his sisters. Like them, he was shown by Holbein holding a book, to symbolise both his learning and the serious and scholarly atmosphere that prevailed in the More household. In the group portrait he stood immediately to the left of his father, his head inclined and his eyes directed (as in the drawing) at the book which he was evidently reading. His pose is reminiscent of that of Erasmus in Massys's portrait of 1517, which was painted for presentation to More by the sitter.

In his last letter, to Margaret Roper, More wrote: 'I pray you at time convenient recommend me to my good son John More. I liked well his natural fashion. Our Lord bless him and his good wife my loving daughter, to whom I pray him be good as he hath great cause'. Little is known about his later life. His grandson, Cresacre More (1572–1649), was the author of a biography of Sir Thomas.

This drawing is on a larger scale than any of the other preparatory studies for the More Family Group. The delicate treatment of the facial features contrasts markedly with the broad strokes with which the cloak, arms and book are depicted. The direction of the diagonal hatching shows clearly that the artist was left-handed.

The inventory of the collection of the late Earl of Arundel, made in 1655, included a large proportion of the works by Holbein known today, and also 'il figliolo de Tomaso Moro', which introduces the possibility that an independent portrait of John More once existed (Cust, p.286).

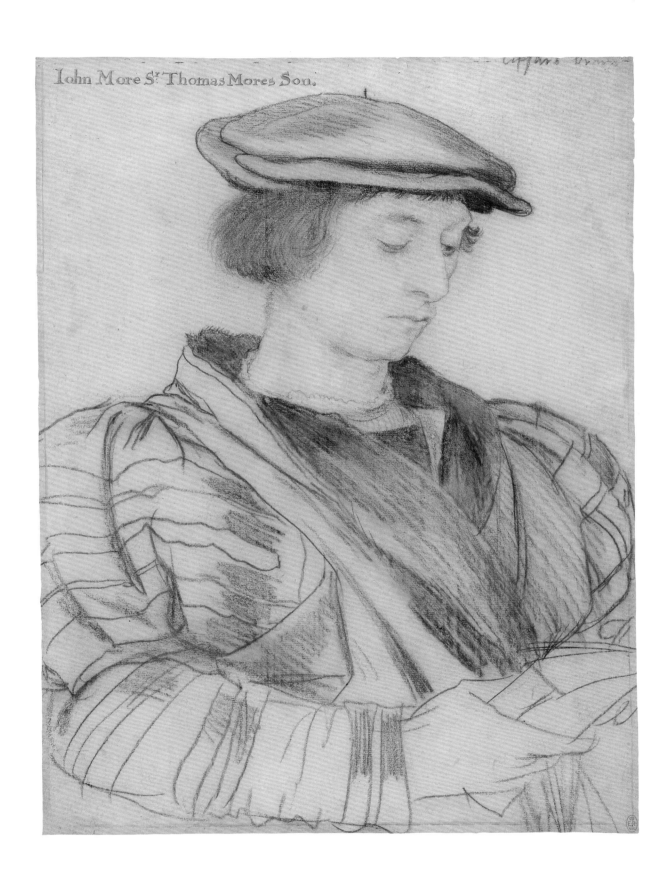

Iohn More Sᵗ Thomas Mores Son.

Anne Cresacre 1512–77

c.1527–8

Black and coloured chalks.
372 × 266 mm. Watermark: two-handled vase with double flower cresting (Briquet 12863).
Parker 7; RL 12270.

Anne Cresacre was the only child of Edward Cresacre of Barnborough (Yorkshire), and was entrusted to the wardship of Sir Thomas More while still an infant. She grew up with the More children and in 1527 became betrothed to John More (no. 4), whom she married in 1529. John and Anne More had eight children. After her husband's death in 1547 she remarried, to George West.

Anne's intimate position in the More household is subtly suggested in the group portrait by her location immediately behind Sir Thomas and Sir John, her gaze directed towards her future husband. The vague shape behind her back in the drawing appears to suggest that she was seated on a chair. In the painting she stands.

As with the portrait of Cicely Heron (no. 3), Holbein's portrayal of Anne's facial features is achieved with a remarkable economy of line and modelling. Although the drawing has probably lost some of its intensity in the last four hundred and fifty years, it remains a telling (and charming) image of a sixteen-year-old girl.

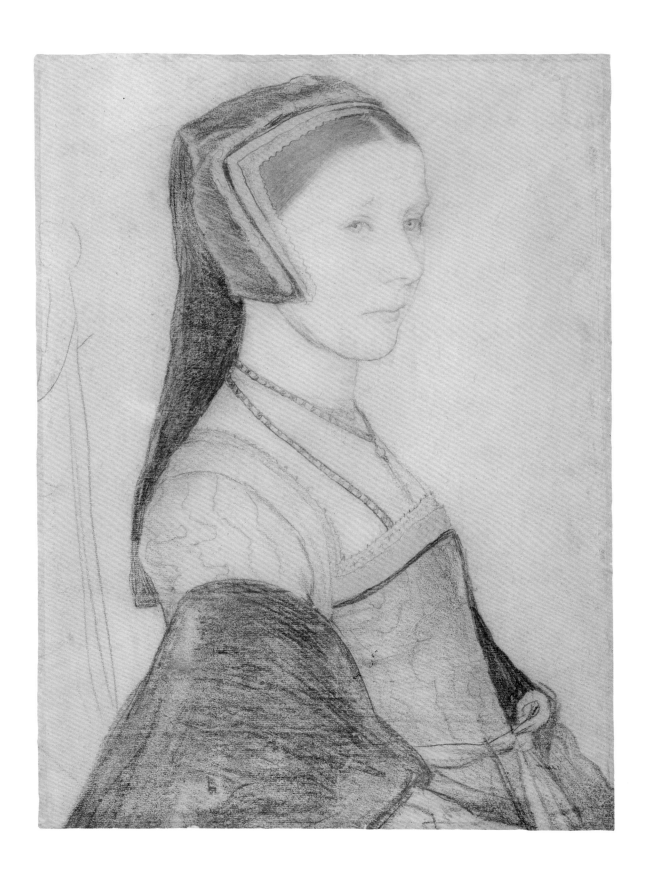

Sir Henry Guildford c.1480–1532

1527

Black, white and coloured chalks, with a touch of pen and ink top right of face. Inscribed in gold over red: *Harry Guldeford Knight*.
383 × 294 mm. Watermark: crowned shield containing three fleurs-de-lys (Arms of France; Briquet 1827).
Parker 10; RL 12266.

Henry Guildford was a year or so younger than Thomas More and was attached to the household of Henry VIII from early in the reign. He was knighted in 1512, appointed Master of the Horse in 1515, Comptroller of the Household in 1522 and Knight of the Garter and Chamberlain of the Exchequer in 1526. In the following year he organised the Greenwich revels, among the recorded payments for which was one to 'Master Hans', who is almost certainly identifiable with Holbein.

Guildford and his wife, born Mary Wotton, were painted by Holbein in a pair of half-length portraits dated 1527 (Royal Collection, Millar 28, and St Louis City Art Museum; Rowlands 25 and 26). A drawing of Lady Guildford, which differs somewhat in pose from the St Louis painting, is in Basel (see p.15). The present drawing is the preparatory study for the painting of Sir Henry. In translating Guildford's likeness from paper to panel, Holbein slightly elongated the facial proportions by raising the cap on the forehead. Guildford's Garter Collar, which is very summarily indicated in the drawing, was shown in glittering detail in the oil painting.

Other significant features to be added in the painting included the Comptroller's white staff and an elaborately decorated hat badge, containing the instruments of the 'Typus Geometriae' as shown in Dürer's engraving entitled *Melencolia* (1514). Guildford was one of Erasmus's English correspondents, and evidently felt justified in wearing his learning on his cap.

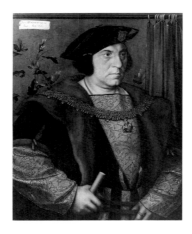
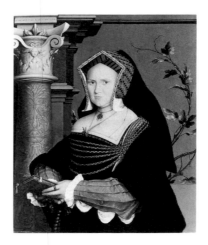

Hans Holbein the Younger *Sir Henry Guildford*, 1527 (oil on panel, 82.6 × 66.4 cm; Royal Collection; Millar 28; Rowlands 25).
Hans Holbein the Younger *Lady Guildford*, 1527 (oil on panel, 87 × 70.5 cm; St Louis Art Museum; Rowlands 26).

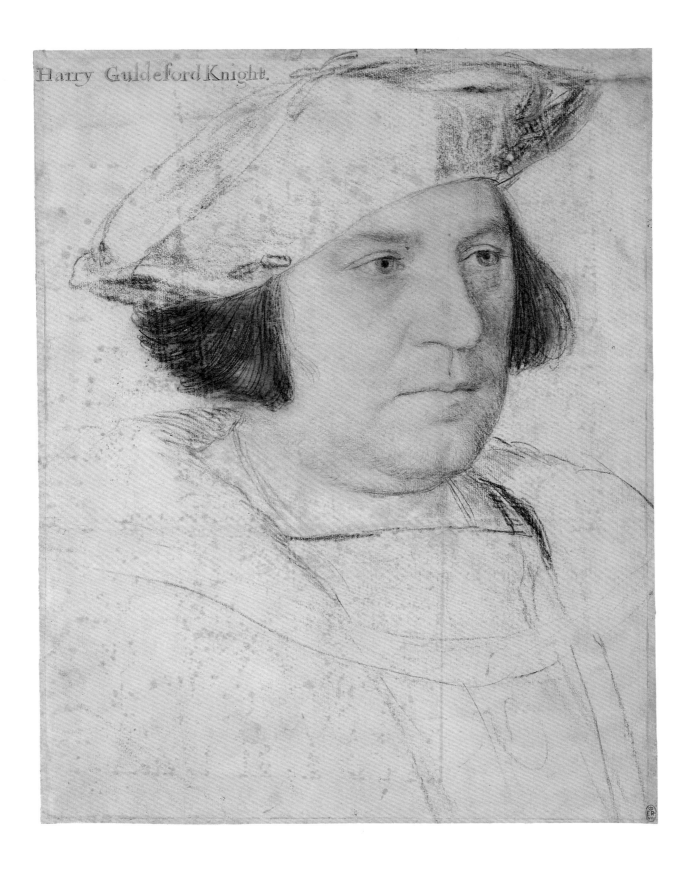

Harry Guldeford Knight.

An Unidentified Lady
c.1526–8

Black and coloured chalks.
Annotated by the artist: *atless* (silk), *dam* (damask), and (?) *ora* (gold).
404 × 290 mm. Parker 11; RL 12273.

The unidentified sitter in this drawing must have been drawn by Holbein at around the time of the artist's first visit to England (1526–8). Although its presence among the Holbein drawings at Windsor might suggest that the sitter was a member of either the More household or the court of Henry VIII, the costume – particularly the headdress – points to a Netherlandish association. Similar headdresses and bodices were recorded by Dürer in the Netherlands in 1520–1.

The materials (silk and damask) referred to in Holbein's notes, and the very fact that the sitter was portrayed, suggest that she was well-to-do. There is a certain parallel (but no similarity) between the agreeable, placid, but not truly beautiful, features of this good lady with those in Holbein's painted portrait of the *Lady with the Squirrel*, recently acquired by the National Gallery (Rowlands 28). The anonymity of the sitter allows us to concentrate on the construction of the headdress, with the entrance and exit of each pin so deftly shown, and the delicate modelling of the face. The drawing was clearly made to be translated into paint, but no related picture is known. The contours do not appear to have been worked over in metalpoint.

Albrecht Dürer *The artist's wife in Netherlandish dress*, 1521
(metalpoint, 407 × 271 mm; Berlin, SMPK, Kupferstichkabinett, KdZ 36).

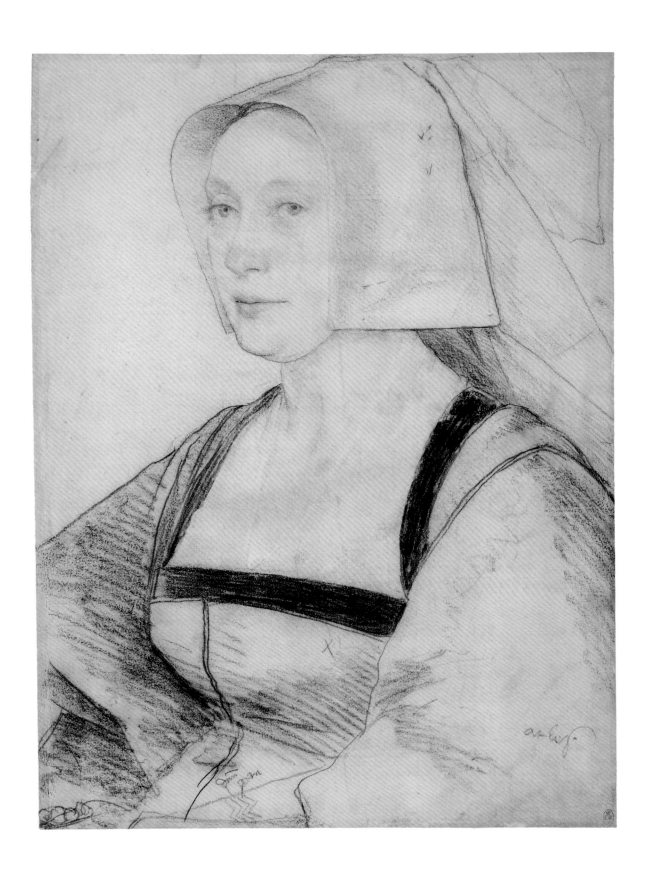

William Warham, Archbishop of Canterbury c.1450–1532

1527

Black, white and coloured chalks, with traces of metalpoint. Inscribed in gold over red: [...]: *Waramus Arch Bᵖ Cant:.*
407 × 309 mm. Watermark: crowned shield containing three fleurs-de-lys (Arms of France; Briquet 1827).
Parker 12; RL 12272.

Warham was the oldest of the Englishmen encountered and portrayed by Holbein. He had an active career as a diplomat, lawyer (Master of the Rolls, 1494), and ecclesiastic (Bishop of London, 1502), before being appointed to the important positions of Archbishop of Canterbury and Primate of England (1503) and Lord Chancellor (1504–15). Although Queen Catherine of Aragon appointed him as her advocate, Warham bowed to the King's demands and initiated the proceedings for his divorce. After Wolsey's death in 1529 Warham had to persuade the English clergy to support the King's wishes. But shortly before his own death in August 1532 Warham publicly voiced his opposition to 'the King's Great Matter'.

Warham had strong ties with the University of Oxford, of which he was Chancellor from 1506. He bequeathed his library to various Oxford colleges. He was a close friend and correspondent of Erasmus from c.1505. In 1524 he received the gift of a portrait of Erasmus by Holbein, sent by the sitter. This is probably the painting, dated 1523, at Longford Castle (Rowlands 13). In return, Warham commissioned Holbein to paint him – in a very similar pose – presumably soon after the artist's arrival in London in 1526. The resulting painting is known in a number of versions, of which the prime original is probably that dated 1527 in the Louvre (Rowlands 27).

This drawing is clearly directly related to the Louvre painting. The measurements of facial features are extremely close. It is possible that the outlines were transferred by tracing, although such metalpoint indentations as are visible on the drawing are not continuous: for instance, they do not extend to the fur collar. As Parker recognised, 'The drawing is unequalled for its penetrating characterisation'.

Hans Holbein the Younger *Archbishop Warham*, 1527
(oil on panel, 82.6 × 66.4 cm. Paris, Musée du Louvre; Rowlands 27).

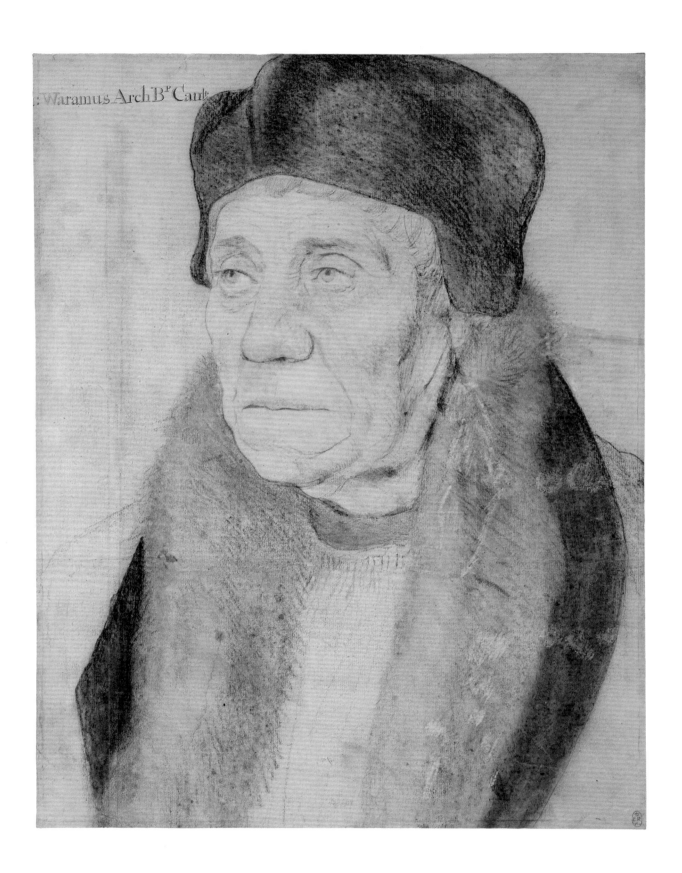
Waramus Arch Bᵖ Cant:

John Fisher, Bishop of Rochester 1469–1535

c.1532

Black, white and coloured chalks, ink applied with pen and brush, and brown-grey wash, on pink prepared paper.
Inscribed in pen and ink: *Il Epyscopo de rosester / fo ... lato Il Capo lano 1535.*
382 × 232 mm. Watermark: hand topped by five-pointed star (variant of Briquet 11341/42).
Parker 13; RL 12205.

Whereas Archbishop Warham's career touched on diplomacy, the universities, the law and the Church, John Fisher, who was twenty years younger, was a single-minded teacher and ecclesiastic. He studied and then taught at Cambridge University, of which he was appointed Chancellor in 1504. On Fisher's advice his patroness, Lady Margaret Beaufort, made many benefactions to both Oxford and Cambridge, but particularly the latter, where her foundations included a Chair of Divinity (which Fisher was the first to occupy from 1503), Christ's College and St John's College. He was also a friend and correspondent of Erasmus.

In 1504 Fisher became Bishop of Rochester. He was a leading figure in the fight against Lutheranism and was also strongly opposed to the King's planned divorce. In consequence of the latter, he was imprisoned in 1534, attainted and executed; shortly before his death he was created Cardinal. He was beatified in 1886 and canonised in 1935. A description of Fisher's appearance has survived from the end of his life: he was tall, slim and strong, with black hair, 'his eyes longe and rounde, neither full black nor full graie, his nose of good and even proportion, somewhat wide mouthed and bigg jawed ... , his skinne somewhat tawnie mixed with manie blew vaines' (quoted in Strong, p.120).

It has not been possible to establish a certain date for this drawing. Whereas in scale it is closer to the works of Holbein's first English period (1526–8), in technique it is similar – but not identical – to those of the second period (1532–43). The sitter's age appears to be closer to sixty-six years (Fisher's age at the time of his death) than fifty-nine (his age in 1528). The fact that no painting of Fisher appears to have been made by Holbein may also support a date c.1532, by which time the Bishop was beginning to fall from favour. The use of black ink, applied with pen and brush, to outline the facial features has created a mask-like impression. But this wonderfully intense image is surely of a living figure.

The curious inscription, in a hand and style unique among the Windsor drawings, has not been satisfactorily explained. In translation it appears to read: 'The Bishop of Rochester [whose] head was cut [off in] the year 1535'. It is possible that this was added while the drawing was in the collection of Thomas Howard, Earl of Arundel, or one of his descendants, around the middle of the seventeenth century: documents relating to items in the Arundel collection were written in a similarly impure Italian. The copy of no.9 in the British Museum, attributed to Rubens by Professor Jaffé, may have been made while the drawing was in Arundel's collection (M. Jaffé, 'Rubens as collector', *Master Drawings*, III, 1965, p.29 and pl.26b). A number of other copies of the Windsor drawing are known. The means by which the outlines of no. 9 were transferred is not known; the contours do not appear to have been redrawn.

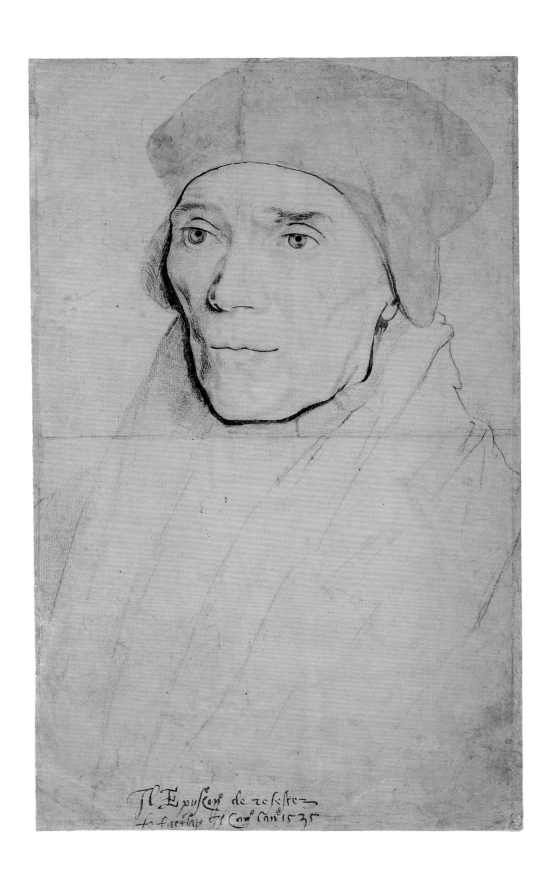

Margaret, Lady Elyot d.1560

c.1532–4

Black and coloured chalks, white bodycolour and black ink on pink prepared paper.
Inscribed in gold over red: *The Lady Eliot*. 278 × 208 mm.
Watermark: crowned shield containing three fleurs-de-lys with diagonal pattern and initials VP (?) below (variant of Briquet 1050).
Parker 14; RL 12204.

Margaret Elyot was the daughter of a Wiltshire gentle-man, Sir Maurice à Barrow, and married Thomas Elyot (no. 11) in 1520. More's biographer, Stapleton, described Elyot as a friend and companion of More's 'in the pursuit of polite literature', adding that his 'wife also gave herself to the study of literature in Sir Thomas More's school' (quoted in S. L. Lehmberg, *Sir Thomas Elyot*, Austin, 1960, p.17). After her husband's death in 1546 Lady Elyot remarried, to Sir James Dyer.

This drawing and its companion, no. 11, were probably drawn at the start of Holbein's second English visit,

the year after the publication of Elyot's *Governor*. In neither drawing do the contours appear to have been traced through, and no related paintings are known. In common with other female sitters portrayed by Holbein, Lady Elyot wears an English hood, the structure of which is clarified by reference to Holbein's drawing in the British Museum (Ganz 150). It is a more complex headdress than that (sometimes called a 'French hood') worn by younger ladies such as Cicely Heron and Anne Cresacre (nos. 3 and 5), and Mary Zouch and Lady Parker (nos. 27 and 28).

Hans Holbein the Younger *Two Views of a Lady wearing an English Hood*
(pen and ink, 159 × 109 mm; London, British Museum, Department of Prints and Drawings; Ganz 150).

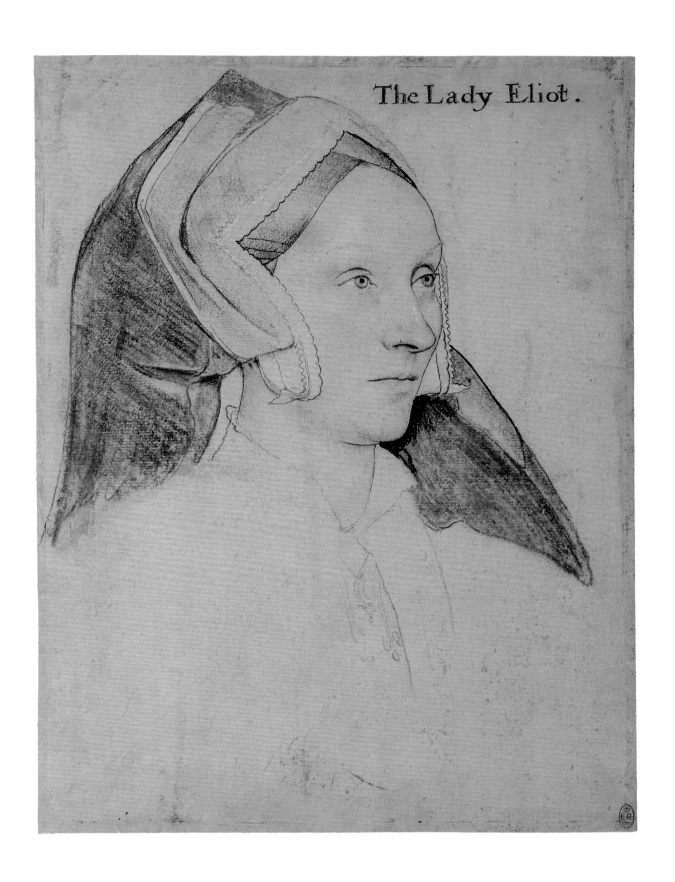

The Lady Eliot.

Sir Thomas Elyot c.1490–1546

c.1532–4

Black and coloured chalks, white bodycolour and black ink on pink prepared paper.
Inscribed in gold over red: *Th: Eliott Knight*. 284 × 205 mm.
Parker 15; RL 12203.

Like his wife (no. 10), Thomas Elyot was born into a family of Wiltshire landowners. He was educated at Oxford and then at the Middle Temple. He served as Clerk to the Justices of Assize (*c.*1510–26) and to the King's Council (*c.*1523–30), and was knighted in 1530. Two years later he was sent as Ambassador to Charles V. He died at Carlton, Cambridgeshire, and was once commemorated (with his wife) in the parish church there by brass likenesses, which have now disappeared.

Contemporaries recorded the friendship between Elyot and More, who must have encountered one another very regularly through both their public and their literary activities. Elyot's best-known work, *The Boke named the Governor* (1531), propounded the educational theories (mostly Italian in origin) which were required to support the state in the modern – humanist – world. Other works, including a Latin-English dictionary, followed in the 1530s. No related painting has survived.

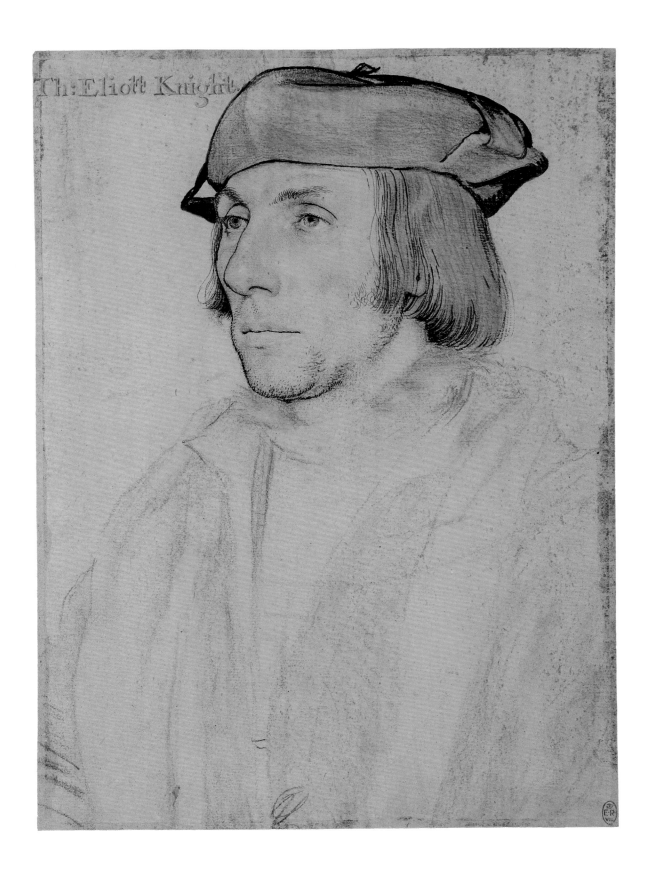

Th:Eliott Knight.

Henry Howard, Earl of Surrey c.1517–47

1532

Black, white and coloured chalks, with pen and ink, on pink prepared paper.
Inscribed in gold over red: *Thomas Earl of Surry*. 248 × 204 mm.
Parker 17; RL 12215.

This drawing was probably made on the same occasion as a drawing of the same sitter facing to the left, also in the Royal Collection (Parker 29). Both are inscribed 'Thomas Earl of Surrey', but must represent Henry Howard, Earl of Surrey, son and heir apparent of Thomas Howard, 3rd Duke of Norfolk.

The Howard family was closely but tempestuously linked to the royal line: the Duke of Norfolk's first wife had been Princess Anne, daughter of Edward IV and sister of Elizabeth of York, but she died childless. The Duke was Lord High Admiral 1513–25, Treasurer of the Household from 1522 and Earl Marshal from 1533.

From *c*.1530, Surrey was the constant companion of Henry VIII's natural son, Henry Fitzroy, Duke of Richmond, who married Mary Howard (Surrey's sister) in 1534 but died two years later. Holbein's portrait of Mary is at Windsor (Parker 16). Surrey had married Frances de Vere (no. 13) in 1532, the probable date of the two exhibited portraits (nos. 12 and 13), which share an uncompromisingly frontal pose. Surrey would have been around fifteen years old at the time.

In 1540 the King married Surrey's cousin, Catherine Howard, following the breakdown of his disastrous fourth marriage (to Anne of Cleves). During the next two years – until Catherine's execution in 1542 – Surrey's life was relatively free from the disturbances and brief periods of imprisonment to which it was otherwise subject. He received the Order of the Garter in 1541. However, in 1546 Surrey and his father were charged with high treason: the King's life was drawing to a close and it was thought – with some justification – that the Howards were planning to seize the young Prince of Wales. Surrey was executed on 21 January 1547; Norfolk's life was saved by the King's own death, on the same day as Surrey's.

Surrey is today best remembered as the poet who was chiefly responsible for introducing blank verse into the English language. His role as patron of the arts might have been better known if his great Norfolk house, Mount Surrey, had survived: it was destroyed soon after 1547.

Neither this drawing nor its companion (no. 13), appear to have been used as patterns for oil paintings. Holbein's portrait of Surrey in São Paulo is around ten years later than no. 12 and Parker 29; it employs a different pose.

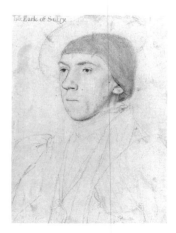

far left
Hans Holbein the Younger
Henry Howard, Earl of Surrey
(oil on panel, 53 × 42 cm;
São Paulo, Museu de Arte;
Rowlands 76).

left
Hans Holbein the Younger
Henry Howard, Earl of Surrey
(black and coloured chalks, with
over-drawing in pen and ink, 288 × 211 mm;
Windsor Castle, Royal Library;
Parker 29).

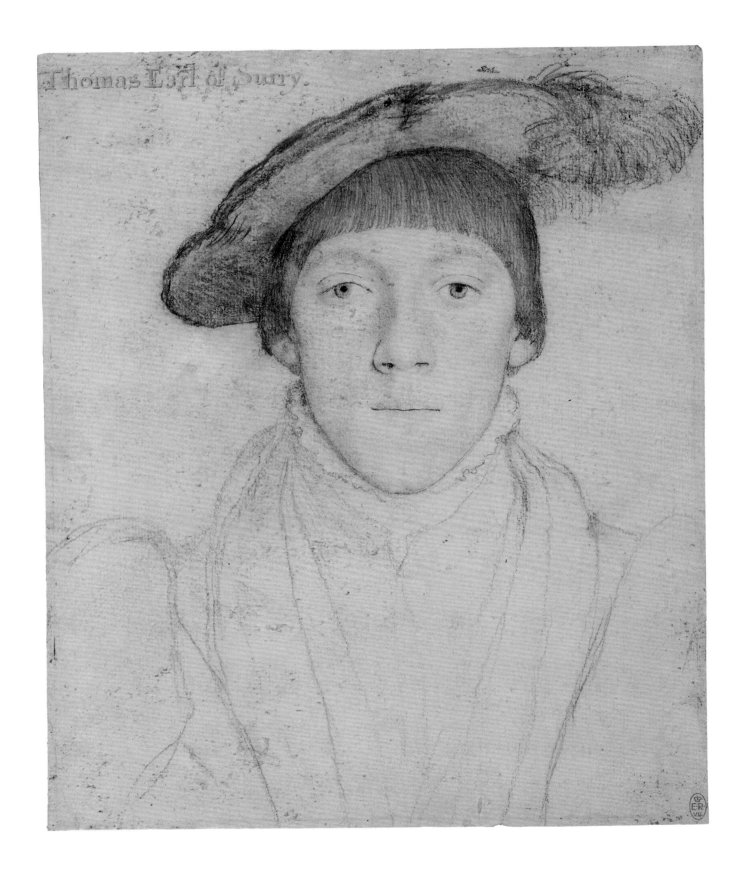

Frances, Countess of Surrey 1517–77

1532

Black, white and coloured chalks, white bodycolour and black ink, on pink prepared paper.
Annotated by the artist: *rosa felbet* (pink velvet), *felbet* (velvet), *schwarz* (black) and (?) *rot* (red).
Inscribed in gold over red: *The Lady Surr'y.* (A second annotation to the left of the sitter's neckline has been deleted.)
310 × 230 mm. Watermark: crowned double-headed eagle, with tailpiece (larger variant of Briquet 1457).
Parker 18; RL 12214.

This drawing is clearly a companion piece to that of Henry Howard, Earl of Surrey (no. 12), and may have been made at around the time of the marriage of the two sitters, in 1532. At the time, both Earl and Countess were around fifteen years old. The Countess was born Frances de Vere, daughter of John, 15th Earl of Oxford. Three daughters and two sons (the eldest of whom succeeded his grandfather as 4th Duke of Norfolk in 1554) lived to adulthood. After Surrey's execution (in 1547), the Countess married Thomas Steynings of East Soham, Suffolk; she died in 1577.

There are no signs of contour reinforcements and no related oil painting is recorded.

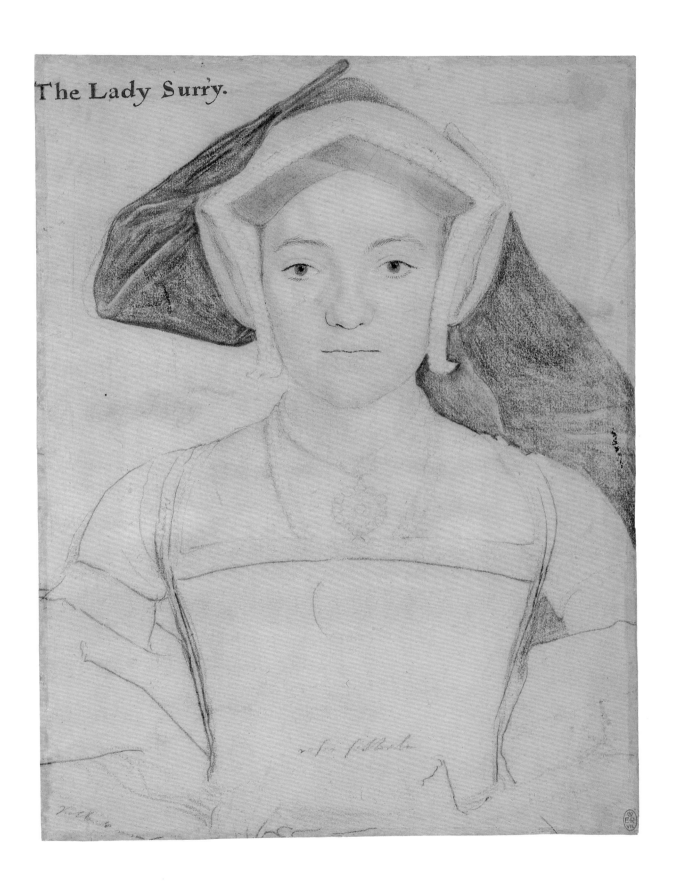

The Lady Surry.

Sir John Godsalve c.1510–56

c.1532

Black, white and coloured chalks, with watercolour and bodycolour, and ink applied with pen and brush on pink prepared paper.
Inscribed in gold over black: *S^r Iohn Godsalue*, and again in gold in a cursive hand (to left of head).
362 × 292 mm. Parker 22; RL 12265.

John Godsalve and his father, Thomas Godsalve, were the subject of a double portrait by Holbein, dated 1528 (Rowlands 31). The elder Godsalve was Registrar at Norwich, but must have been portrayed in London, shortly before Holbein's departure for Basel. At the time of the Norwich subsidy assessment of 1524, he was among the fourteen richest men in the city. He was a close friend of Thomas Cromwell, to whom he sent (in November 1531) 'half a dozen swans of my wife's feeding' in return for many kindnesses shown to his son. The son, John (shown here), followed his father in public office both in Norwich and then in London, where he was appointed Clerk of the Kings's Signet in 1531; in the following year he received a grant in survivorship of the office of Common Meter in Precious Tissues. This would invevitably have brought him into contact with the Hanseatic merchants in London, many of whom were portrayed by Holbein on his return from Basel in 1532. John Godsalve participated in the French campaign in 1544; in the same year, 'John Godsalve esq, mercer' was admitted Freeman of Norwich. He was knighted in 1547 and in the following year became Comptroller of the Royal Mint. At the time of his death, he was the lord of eleven Norfolk manors. (For bio-

graphical information, see A. Moore and C. Crawley, *Family and Friends*, exhibition catalogue, Norwich, 1992, no.4.)

A comparison between Godsalve's appearance in the double portrait and in no. 14 suggests that the latter may date from c.1532, the time of the Steelyard portraits. A third portrait of Godsalve, in Philadelphia (Rowlands R.19), may derive from another image of the same sitter made at around the same time. It is not autograph.

The portrait of Godsalve is exceptional in the Windsor series because of its high degree of finish, the blue ground, and the *trompe l'œil* effect of the hand resting on the ledge. It is possible that it was intended as a finished work of art. It may have been destined for application to a panel – as was the case with several other finished studies by Holbein. It is not possible to suggest how it came to survive alongside the other more strictly preparatory studies in the same series, although the reference to a 'ritratto d'homo aquazzo' by Holbein in the posthumous inventory (dated 1655) of pictures belonging to the Earl of Arundel may be relevant, for the great book also belonged to the Earl (Cust, p.323). The fine brush modelling in the face looks forward to Holbein's work as a miniaturist, from c.1535.

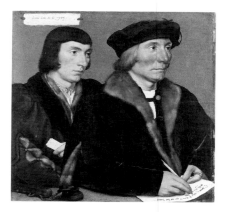

far left
Anonymous artist after Holbein
John Godsalve
(oil on panel, 32.7 × 24.6 cm;
Philadelphia Museum of Art,
John G. Johnson Collection,
inv. no. 35; Rowlands R.19).

left
Hans Holbein the Younger
John and Thomas Godsalve, 1528
(oil on panel, 35 × 36 cm; Dresden,
Gemäldegalerie Alte Meister; Rowlands 31).

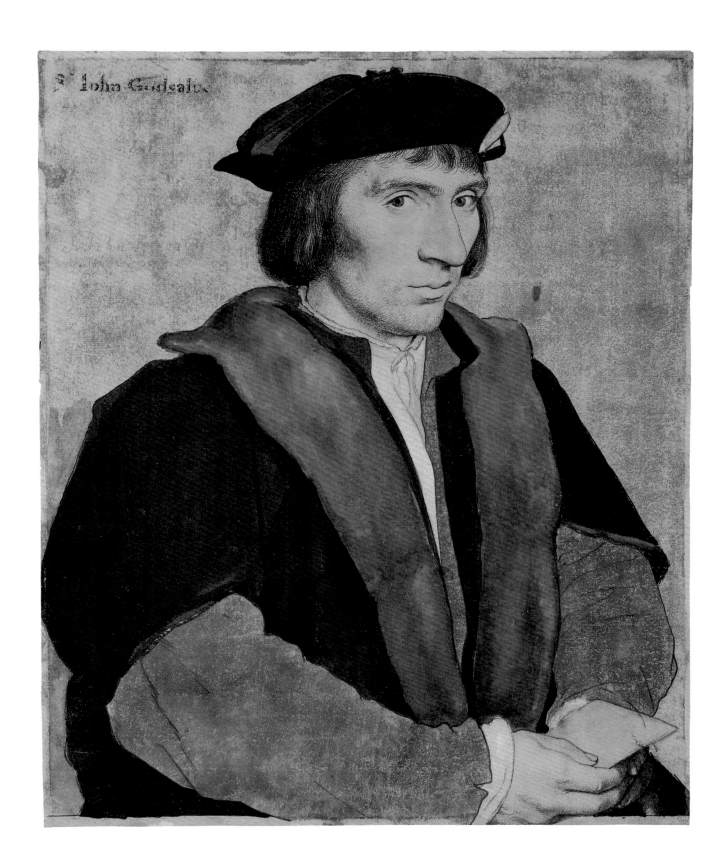

S John Godsalue

≈ 15 ≈

James Butler, 9th Earl of Wiltshire & Ormond 1504–46

c.1533

Black, white and coloured chalks, watercolour, bodycolour and ink applied with pen (?) and brush, on pink prepared paper.
Inscribed in gold over red (in a cursive hand): *Ormond*. 401 × 292 mm.
Watermark: two-handled vase with double flower cresting (Briquet 12863).
Parker 23; RL 12263.

The old identifying inscription, 'Ormond', has led to some confusion concerning the subject of this drawing. There were for a time two rival claimants to the Earldom of Ormond (or Ormonde): Thomas Boleyn (1477–1539) and James Butler (c.1504–46). The former, the father of Anne Boleyn, was considered the most obvious candidate, although it was remarked that the drawing appeared to show someone younger than fifty (Boleyn's age at the time of Holbein's first visit to England).

David Starkey has plausibly suggested that the drawing instead represents James Butler, son of Piers Butler, the illegitimate kinsman of the 7th Earl of Ormond (died 1515) and claimant to his title and lands (D. Starkey, 'Holbein's Irish Sitter?', *Burlington Magazine*, CXXIII, 1981, pp.300–3). Butler was brought up at the English court and was appointed an Esquire of the Body in 1527. A plan to unite the rival English and Irish claimants to the Ormond title through the marriage of Butler and his cousin (and exact contemporary), Anne Boleyn, came to nothing. Butler remained unscathed following the fall of Anne, who married Henry VIII in January 1533

and was executed for adultery in May 1536. In 1535 he had been appointed Admiral of Ireland and a Privy Councillor and in October 1537 he attended the christening of Prince Edward. Butler succeeded his father as Earl of Ormond in 1539. He died in October 1546, apparently having been poisoned during a visit to London.

From this biographical outline, it is difficult to suggest when Holbein's portrait drawing might have been made. No painting of Butler appears to exist and there is no indication that the outlines have been traced through. In scale, no. 15 is closer to Holbein's drawings of the 1520s than of the 1530s or 1540s. However, with its coloured ground it would more naturally be dated from after 1532. It is possible that it was intended to become a finished portrait (like that of Godsalve: no. 14), but remained incomplete. Although Ormond's costume – broad-shouldered, slashed and strapped – is similar to that worn by Henry VIII in the Whitehall mural of 1537, approximately the same style was worn by the so-called 'Ambassadors' portrayed by Holbein in 1533 (Rowlands 47) and by François I in portraits of the 1520s. On balance, a date c.1533 seems probable.

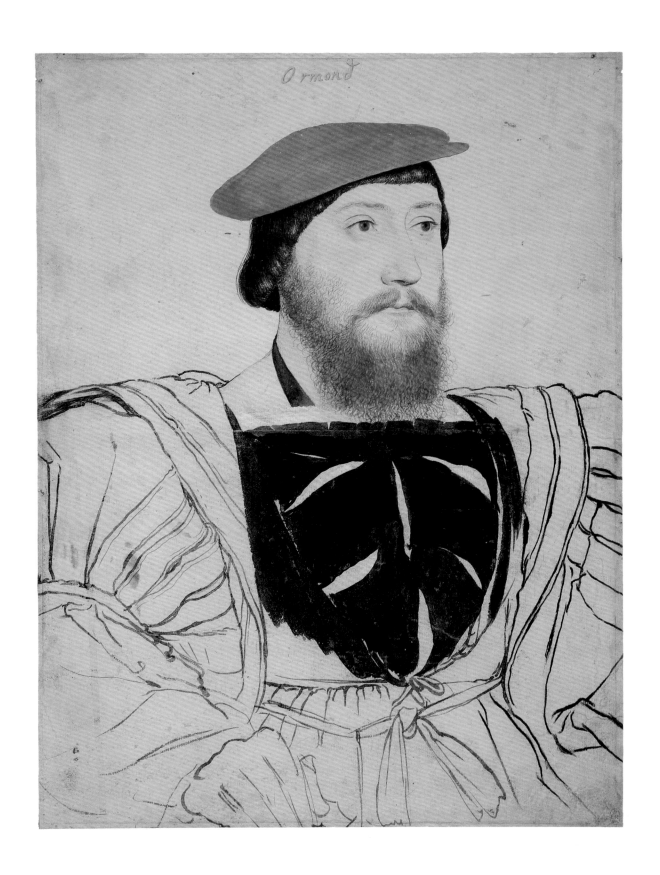

Ormond

William Reskimer d.1552
c.1532–3

Black, white and coloured chalks, with metalpoint over-drawing, on pink prepared paper.
Inscribed in gold over red: *Reskemeer a Cornish Gent:.*
290 × 210 mm. Parker 31; RL 12257.

Two members of the family of Reskimer (variously spelt Reskymer, Reskemer or Reskimer), of Merther, near Truro, occupied minor positions at Henry VIII's court. But after being in attendance on Wolsey in 1521, the elder brother, John, appears to have retired to his Cornish estates. It therefore seems more likely that Holbein's drawing represents the younger brother, William, who is recorded at court continuously from 1526 (as Page of the Chamber) through the 1540s. In 1543 he became Keeper of the Posts of the Duchy of Cornwall and in 1546 was appointed Gentleman Usher. His will (Greater London Record Office, DL/C/356, f.121) was recently discovered by Dr Lorne Campbell. At the time that the document was drawn up (8 April 1552), William Reskimer was a resident of Hendon, Middlesex; he was survived by his wife (Alice Densil: they appear to have married in 1540), one son and four daughters.

The drawing is a preparatory study for the oil painting in the Royal Collection (Millar 31; Rowlands 39). The picture was noted in Van der Doort's inventory of Charles I's collection as 'a side faced Gentleman out of Cornwall', without further identification; it had been given to the King by Sir Robert Killigrew (d.1633). Sir Robert's first cousin, Elizabeth Killigrew, was the wife of Jonathan Trelawny, grandson of William and Alice Reskimer (ex-inf. Dr Lorne Campbell). The facial features and outlines of the hat, head and shoulders are followed very closely in the oil painting. As all the principal contours appear to have been over-drawn in metalpoint, they were presumably traced through to the panel, using a carbon-covered intermediary sheet.

In the painting the figure and background are extended on all four sides, to show the arms and hands. The right hand is curved back – somewhat uncomfortably – to touch the end of Reskimer's distinctive red beard. The background of the painting contains vine tendrils against a plain colour, as previously seen in the paintings of the Guildfords (1527), in the *Lady with the Squirrel* and in Derich Born (1533). Technically, the drawing appears to date from Holbein's second English visit. On balance, both drawing and painting should probably be dated c.1532–3.

Hans Holbein the Younger *William Reskimer* (oil on panel, 46.4 × 33.7 cm; Royal Collection; Millar 31; Rowlands 39).

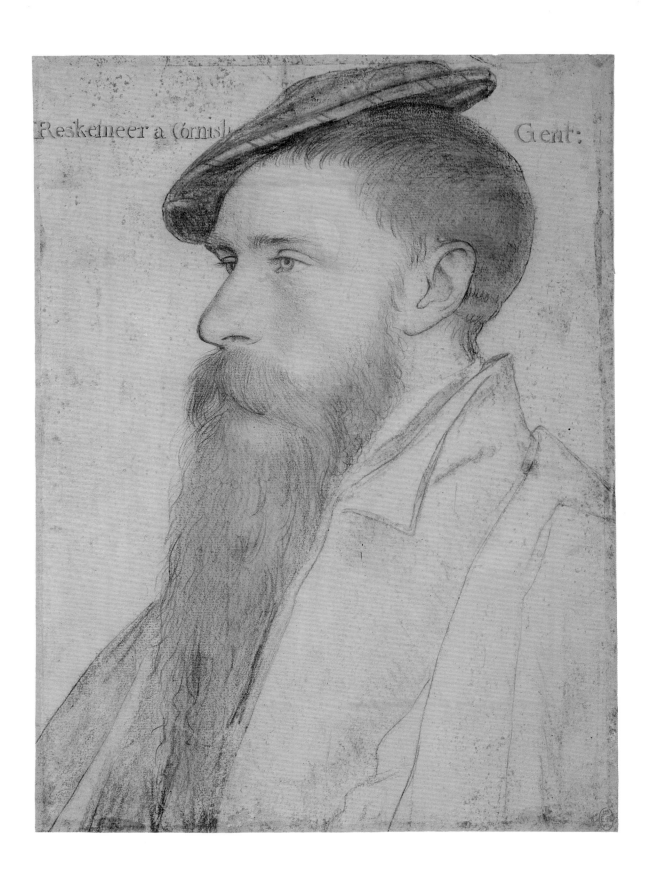

Reskemeer a Cornish Gent:

≈ 17 ≈

An Unidentified Gentleman

c.1532–4

Black, white and coloured chalks, with black ink applied with pen and brush, on pink prepared paper.
Annotated by the artist, in ink: *atlass* (silk), *at* (for *atlass*, silk) twice, and *S* (? satin or schwarz: black).
272 × 210 mm. Watermark: two-handled vase with double flower cresting (Briquet 12863).
Parker 32; RL 12258.

The annotations (in Holbein's hand) on the jacket and shirt confirm that this drawing is a preparatory study rather than a finished portrait. However, there does not seem to be any sign of metalpoint over-drawing in no. 17 and no related painting is known. That one may once have existed is suggested by an etching by Hollar which claims to record a painting in Arundel's collection (Parthey 1547). It omits the inscriptions and, through Hollar's sophisticated etching technique, shows a variety of different shades and textures of material. Hollar's portrait has a circular format, similar to the small roundels related to nos. 18 and 19. There are two possible candidates among the unnamed portraits by Holbein in the Arundel inventory of 1655: 'ritratto de homo con berettino negro' and 'ritratto d'homo con beretino negro piccolo' (Cust, pp.284 and 286).

The fact that no identifications are given on either the drawing or the Arundel inventory, coupled with the style of dress, may suggest that the sitter was a foreigner, possibly from France. Holbein's portraits of 'The Ambassadors' (Jean de Dinteville and Georges de Selve: Rowlands 47) and of Charles de Solier, Sire de Morette (Rowlands 53), were painted in London in 1533 and 1534 respectively.

In spite of the damage inflicted on the Windsor Holbein drawings over the years, the coloured chalk modelling in this drawing remains clearly legible. The sitter's broken nose (also indicated in the etching), the thick wiry growth of his beard, and the rather darker shade of his hair, show Holbein working to advantage with ink and wash – applied with pen and brush – and with coloured chalks.

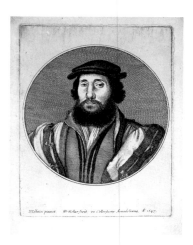

Wenceslaus Hollar after Holbein *An Unidentified Gentleman*, 1647
(etching, 128 × 108 mm; Windsor Castle, Royal Library; Parthey 1547).

[58]

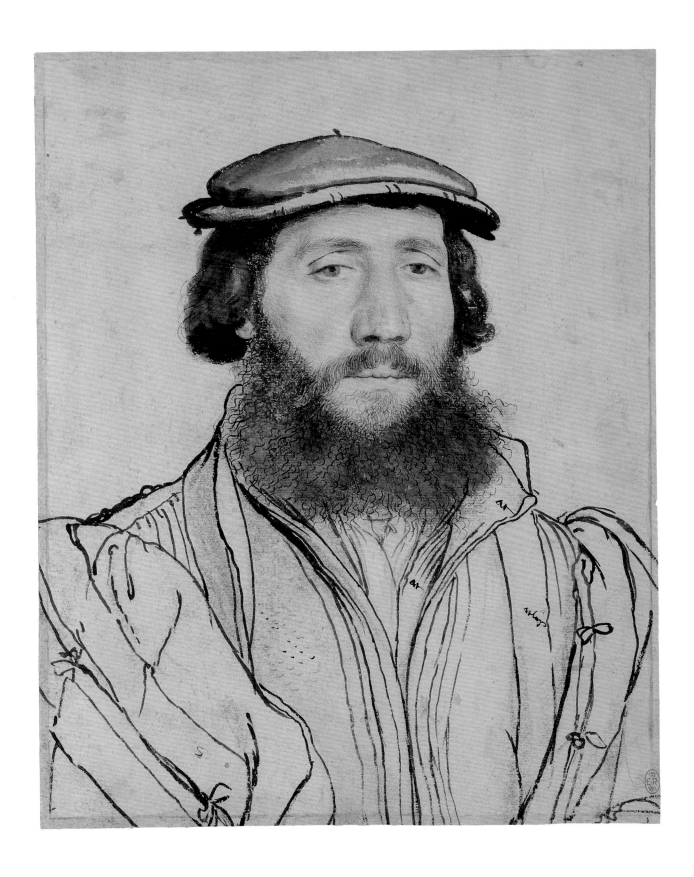

An Unidentified Gentleman

1535

Black, white and coloured chalks, with over-drawing in ink and metalpoint, on pink prepared paper.
296 × 222 mm. Parker 33; RL 12259.

As with no. 17, the man shown in this drawing must have been unknown to Sir John Cheke and therefore remains unidentified. However, the inscription on the related oil painting (Rowlands R.22) states that it was executed in 1535, of a man aged twenty-eight.

The painting (a roundel) follows the drawing in all essentials, but includes more to right and left, and shows the sitter's left hand holding a pair of gloves in the foreground. As in the case of the painting of Reskimer (see no. 16), it also makes effective artistic use of the loose tie-strings attached to the shirt collar.

Recent scientific analysis of the oil painting has shown that the under-drawing follows the outlines of the drawn portrait very precisely, and specifically in those areas (the ear, collar contour, on the hat, hair and clothing, and on the shirt) where there are signs of metalpoint or pen and ink over-drawing (Ainsworth, fig. 22). The contours must have been transferred by tracing, and with the use of an intermediary carbon-covered sheet. The technical study (by Maryon Ainsworth) has also revealed that the under-drawing in the New York painting is more extensive than that normally found in Holbein's paintings. The oil painting is thought to be by a close follower of Holbein, 'very likely trained in his studio' (Rowlands, p.114); it may be a product of his workshop (Ainsworth, p.183). It shares with another workshop product, the portrait of Jane Seymour in The Hague (Rowlands R.23), a distinctive surface boundary surrounding the figure, which appears to be painted on a very slightly sunken area of the panel.

 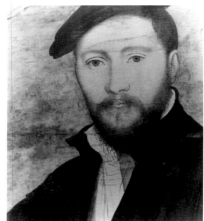

left
Workshop of Hans Holbein the Younger *An Unidentified Gentleman*, 1535
(oil on panel, diam. 30.5 cm; New York, Metropolitan Museum of Art, the Jules S. Bache Collection, 1949 (49.7.28); Rowlands R.22).
right
Infra-red reflectogram computer assembly: detail of the head and shoulders in the portrait of *An Unidentified Gentleman*
(New York, Metropolitan Museum of Art; photograph reproduced by courtesy of the Paintings Conservation Department).

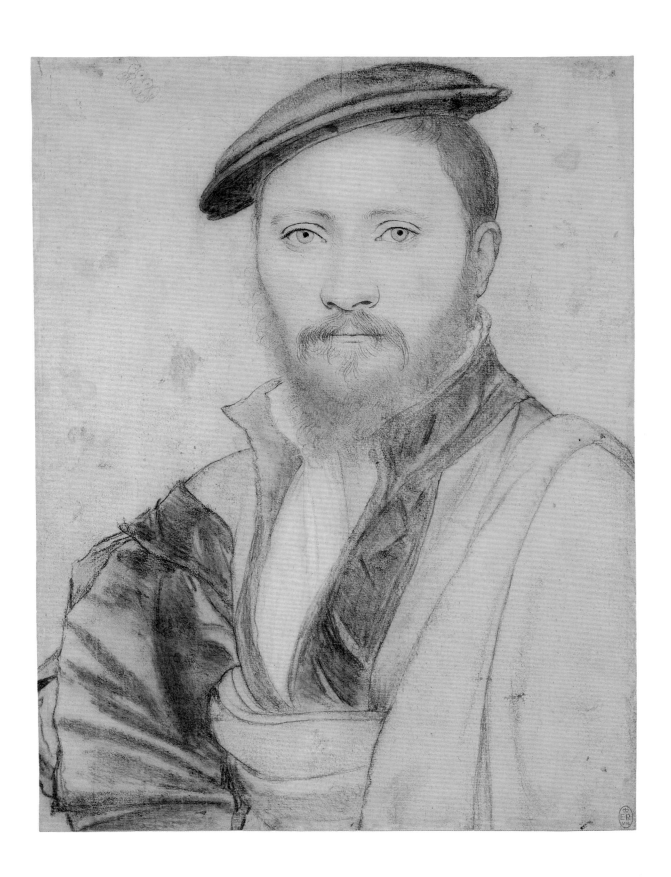

Simon George

c.1535

Black and coloured chalks, and black ink applied with pen and brush, and metalpoint over-drawing, on pink prepared paper.
Inscribed in gold over red (in a cursive hand): *S. George of Cornwall*. 279 × 191 mm.
Watermark: crowned shield topped by flower, containing cross and goose (Briquet 1255).
Parker 35; RL 12208.

This drawing is closely related to the painted roundel in the Städelsches Kunstinstitut, Frankfurt (Rowlands 63), in which the sitter's right hand (holding a pink) is included, and his plumed cap is adorned with jewels and flowers. The only possible candidate for identification with the inscription ('S. George of Cornwall') would seem to be Simon George, who is named in an early heraldic visitation of Cornwall. However, as Simon George is not recorded at court, the circumstances in which he came to be painted by Holbein – presumably in London (far remote from either Cornwall or his native Dorset), and wearing such fine attire – are not known. It has been plausibly suggested that the portrait was made at the time of the sitter's betrothal or marriage, symbolised by the flower that he holds. In such a case, it might have been a companion piece to a female portrait, in profile to the right.

The oil painting has been the subject of technical analysis using both x-radiography and infra-red reflectography (Ainsworth, figs. 15 and 16. See also her earlier article: 'Northern Renaissance Drawings and Under-drawings', *Master Drawings*, XXVII, no.1, 1989, p.17). From these it appears that the outlines of the main features of the face and head were traced (using a metalpoint and an intermediary 'carbon paper' sheet) from Holbein's drawing to the painted panel, and that the reinforced contours of the drawing were subsequently strengthened (by Holbein) with pen and ink. A few faint unreinforced metalpoint lines are apparent in the lower part of the drawing. The under-drawing, like the drawing, showed the sitter with a moustache but without a beard. A separate (lost) drawing was probably used, and traced through, to provide the contours of the hand (Ainsworth, p.180).

far left
Hans Holbein the Younger
Simon George (oil on panel,
diam. 31 cm; Frankfurt, Städelsches
Kunstinstitut; Rowlands 63).

left
Infra-red reflectogram assembly:
detail of the head in Holbein's
portrait of Simon George (Frankfurt,
Städelsches Kunstinstitut;
photograph reproduced by courtesy
of the Paintings Conservation
Department, Metropolitan Museum
of Art, New York).

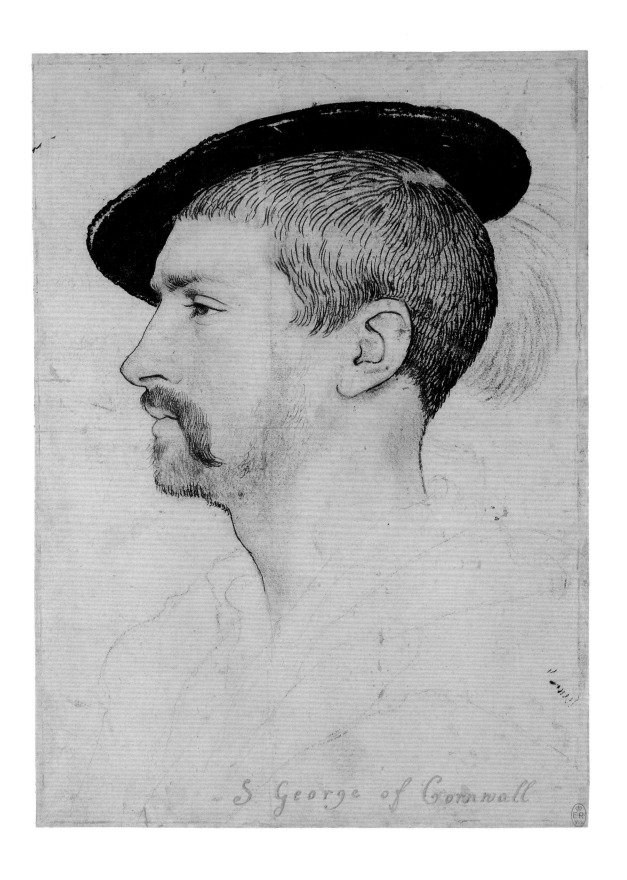

S George of Cornwall

Sir Richard Southwell 1504–64

1537

Black and coloured chalks with ink, applied with pen and brush, and metalpoint over-drawing, on pink prepared paper.
Annotated by the artist, in pen: *Die augen ein wenig gelbatt* (the eyes a little yellowish), and in chalk: [A]NNO ETTATIS SVA[E]/.33.
Inscribed in gold over red: *Rich: Southwell Knight.*
366 × 277 mm. Watermark: crowned double-headed eagle, with tailpiece (larger variant of Briquet 1457).
Parker 38; RL 12242.

Richard Southwell was one of Thomas Cromwell's most loyal and unscrupulous henchmen. His father, Francis, was a wealthy Norfolk squire. In 1532 Richard received a pardon for a charge of murder (on payment of the considerable sum of £1000), and two years later was appointed Sheriff of Norfolk and Suffolk. He was present in the Tower of London during the interrogation of Sir Thomas More by Richard Rich in 1535, but when questioned during More's trial claimed that he had not heard the answers which More had given to Rich's questions (which were falsely reported by Rich) as he was occupied removing More's books. In 1536 Southwell became Receiver to the Court of Augmentations, the newly-established government department which administered the transfer of monastic lands to the crown. Holbein's portrait of Southwell is datable 1537. Southwell was elected MP for Norfolk in 1539, was knighted in 1540, and assisted in the prosecution and conviction of his childhood friend, the Earl of Surrey (no.12), which ended in Surrey's execution in 1545. He was a Privy Councillor under both Edward VI and Queen Mary, but was imprisoned 1549–50 after declaring his Catholic faith, and was likewise out of favour under Queen Elizabeth.

This drawing is the preparatory study for Holbein's oil painting of Southwell (Rowlands 58), inscribed as painted in the twenty-eighth year of the King's reign, i.e. 1537. The painting was presented to Grand Duke Cosimo II by Thomas Howard, Earl of Arundel, in 1620 and has remained in Florence ever since. It shows Southwell in a jacket of velvet and satin, his black cap adorned with a circular hat badge, probably incorporating an agate figure of Lucretia in a gold setting. Around his neck he wears a heavy interlocking gold chain. The figure is placed against a plain green background.

The painting follows the drawing (which omits the hands and details of the hat badge and chain) in all essentials. The three blemishes on the face and neck, which Parker and previous writers described as patched holes, are very meticulous descriptions of scars and are shown in the oil painting. In the painting the line of the back of the neck follows the inner ink line of the drawing rather than the outer chalk line. Metalpoint over-drawing is clearly visible on the lower part of the sheet. We may therefore assume that – as with nos. 18 and 19 – the contours of the figure were traced through to serve as the under-drawing for the painting, and the drawing of the face and neck were then reinforced with ink.

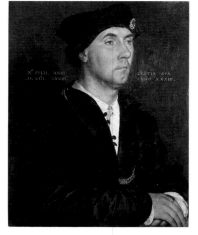

Hans Holbein the Younger *Sir Richard Southwell* (oil on panel, 47.5 × 38 cm; Florence, Uffizi; Rowlands 58)

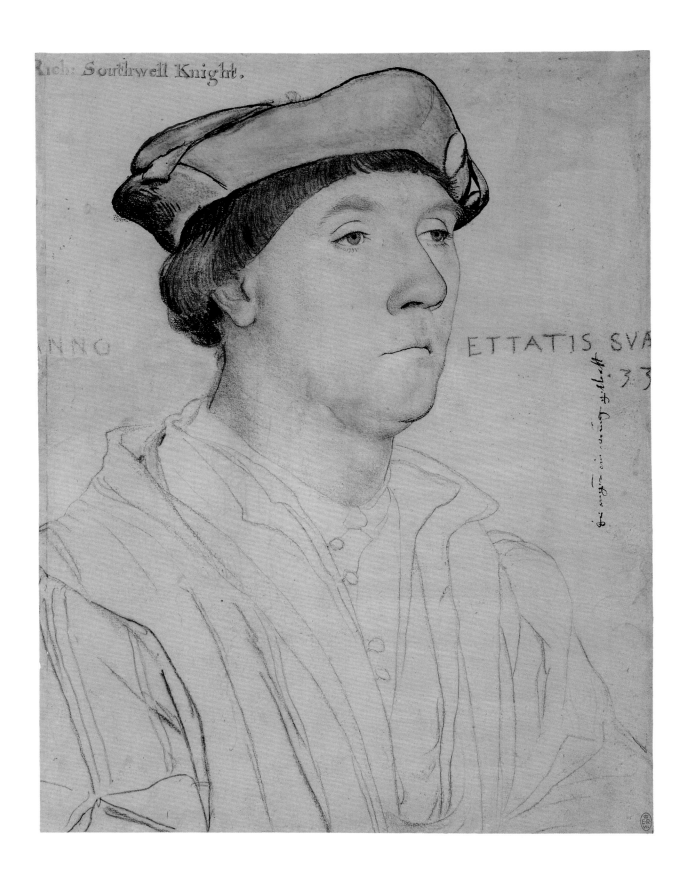

Rich: Southwell Knight.

ANNO ETTATIS SVA
 · 3 3

Queen Jane Seymour c.1509–37
1536–7

Black and coloured chalks, with over-drawing in metalpoint and pen and ink, on pink prepared paper.
Inscribed in gold over red: *Iane Seymour Queen*. 500 × 285 mm. (With a horizontal join 65 mm from the bottom of the sheet
and old fold-lines 10 mm below this and 145 mm above this.)
Parker 39; RL 12267.

Jane Seymour was the daughter of John Seymour (*c*.1476–1536) of Wiltshire, who was knighted in 1513 as a reward for loyal service at home and abroad. Several members of his family were at court. Jane served as Lady-in-Waiting to both Catherine of Aragon and Anne Boleyn. By February 1536 her name was linked romantically with that of the King. Three months later, on the day following the execution of Queen Anne, Jane and Henry became formally betrothed; they were married on 20 May 1536. Their child, the King's long-awaited son and heir (the future Edward VI), was born on 12 October 1537, but Queen Jane died twelve days later. During the brief period of their marriage, Henry VIII had caused the interlocked initials *H* and *I* to be used as decorative devices in the newly-decorated rooms at Hampton Court. He was distraught after her death.

Jane's marriage and the birth of Prince Edward resulted in honours and high offices being heaped on her brother, Edward Seymour. He was appointed one of Henry VIII's executors and then Governor of his nephew, Edward VI. Soon after the start of the new reign he was created Duke of Somerset, Earl Marshal and Protector of the Realm. But he was later indicted and in 1552 was executed.

The Queen's features were described by the Imperial ambassador at around the time of her marriage. She was 'of middle stature and no great beauty, so fair that one would rather call her pale than otherwise'. However, the paleness of this drawing

must arise from its use and re-use over many years: very little coloured chalk has survived. We are left with the metalpoint outlining to the main contours of the head and body, used to transfer these contours to the painter's panel. Queen Jane's portrait continued to appear in royal groups long after her death, a likeness which was always based – however indirectly – on the present drawing. The likeness was probably taken in the second half of 1536. 'Cut-off' points for independent portraits may be suggested by the three horizontal lines (one drawn, two folded) across the lower edge of the sheet.

The only surviving oil painting of the Queen which appears to be an autograph work by Holbein is that in Vienna (Rowlands 62). By placing an actual size transparent photocopy of the drawing over the painting, it can be shown that the contours match precisely, except for small areas in the shoulder and bust. The underdrawing in the Vienna painting is limited to precisely those facial features which were (later) reinforced in the

drawing, in pen and ink. Ainsworth considers that the pen reinforcements are in Holbein's hand, and there seems to be no good reason to doubt this (Ainsworth, p.181). However, the exclusive use of metalpoint over the chalk drawing elsewhere on the sheet is surely not all Holbein's personal responsibility. The portrait of Jane Seymour in The Hague is a reduced version of the image in the present drawing, and appears to be by an English follower of Holbein (Rowlands R.23).

Hans Holbein the Younger *Queen Jane Seymour* (oil on panel, 65 × 40.5 mm; Vienna, Kunsthistorisches Museum; Rowlands 62).

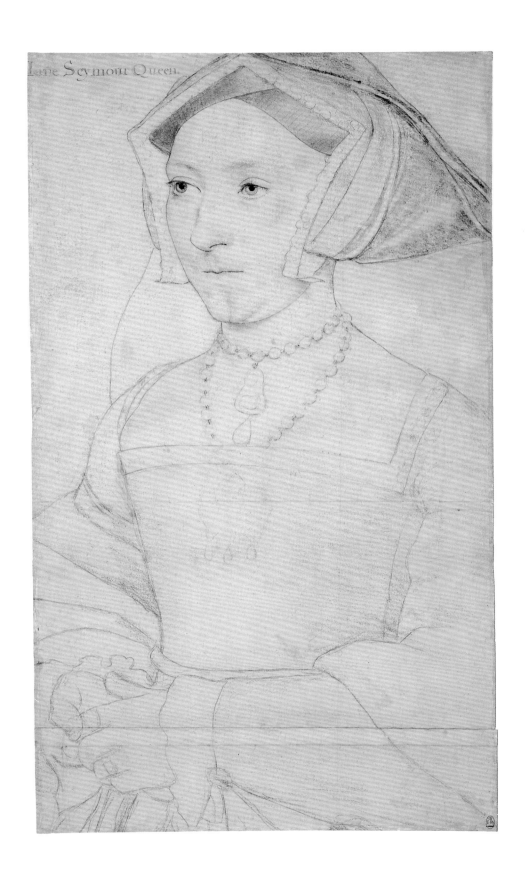

George Brooke, 9th Baron Cobham c.1497–1558

c.1540

Black and coloured chalks, with over-drawing in metalpoint and pen and black ink, on pink prepared paper.
Inscribed in gold over red: *Brooke Lᵈ Cobham*. 289 × 203 mm.
Parker 53; RL 12195.

George Brooke was the son of Thomas Brooke, 8th Baron Cobham. He was frequently at court and received a knighthood in 1523, after the capture of Morlaix. He was a strong supporter of the King and participated in the trial of Anne Boleyn in 1536. At the Dissolution of the Monasteries he received generous grants of ecclesiastical land. In June 1544 he became Deputy (or governor) of Calais; two years later he was Lieutenant-General in the Scottish campaign. His royal service was rewarded with appointment to the Order of the Garter in 1549. Cobham's sister, Elizabeth, was married to Sir Thomas Wyatt the Elder (no. 25). Under Queen Mary, Cobham was involved in the rebellion of Sir Thomas Wyatt the Younger, but was pardoned.

The drawing is related to a painting which surfaced in the London salerooms in 1969 (Rowlands R.38). The painting is inscribed GEORGIVS DOMINVS DE COBHAM GVBERNATOR CALETTI ET PATER GVLIHELLMI DE COBHAM. The inscription was evidently added after 1544, and also after William, 10th Baron Brooke (1527–97), had reached maturity. The painting itself may be a work of the 1550s: it is not by Holbein. Without technical examination of the panel it is not possible to say whether the outlines of the present drawing were traced or merely copied for the painting. The metalpoint lines along the contours of the drawing show that outline tracing was carried out, but not necessarily in connection with Rowlands R.38.

Anonymous artist after Holbein *George Brooke, 9th Baron Cobham*
(oil on panel, 31.2 × 31.2 cm; Germany, private collection; Rowlands R.38).

Brooke Ld Cobham.

John Poyntz d.1544

c.1535

Black, white and coloured chalks, with over-drawing in pen and black ink and traces of metalpoint, on pink prepared paper.
Inscribed in gold over red: *Iohn Poines*. 295 × 233 mm.
Watermark: hand with figure 3 in palm, topped by five-pointed star (variant of Briquet 11369).
Parker 54; RL 12233.

Two drawings at Windsor are identified as portraits of members of the Poyntz family: the present one as 'John Poines' and Parker 34 as 'N. Poines Knight'. There are painted copies of both drawings at Sandon Hall (collection of the Earl of Harrowby: see under Rowlands R.24). That of no. 23 bears the coat of arms of John Poyntz of Alderley, Gloucestershire, son of Sir Robert Poyntz of Iron Acton, Gloucesteshire (*d.*1532), and uncle of Sir Nicholas Poyntz. John was probably an MP in 1529 and a member of Anne Boleyn's household. Two of Wyatt's satires of the later 1530s were addressed to 'mine own John Poyntz' (E. W. Ives, *Anne Boleyn*, Oxford, 1986, p.9). John Poyntz fought in France in 1544, the year of his death. His first wife, Elizabeth, was a sister of Sir Henry Guildford (no. 6).

It is possible that the drawings of both John and Nicholas Poyntz date from summer 1535, when Henry VIII, Anne Boleyn and the royal court stayed with Sir Nicholas at Iron Acton on their royal progress. The new eastern range there, decorated and furnished in the latest Renaissance taste specifically for this visit, has recently been surveyed by English Heritage (see *Henry VIII*, p.118–25).

Whereas the drawing of Sir Nicholas is in profile facing left, that of John Poyntz employs an unusual stance, with the sitter's back occupying much of the lower part of the sheet. The upward glance is reminiscent of that of a donor in a religious painting, for instance Jacob Meyer zum Hasen in Holbein's Darmstadt Madonna (Rowlands 23). No painting of John Poyntz by Holbein himself appears to survive. The ink and metalpoint over-drawing in no. 23 indicate that this drawing was traced over, possibly for transfer to the Sandon panel.

William Parr, 1st Marquess of Northampton 1513–71
1541–2

Black and coloured chalks with white bodycolour, ink applied with pen and brush, on pink prepared paper.
Annotated by the artist, in black ink: *wis felbet* (white velvet), *burpor felbet* (purple velvet), *wis satin* (white satin), *w* (for *weiss*, white)
five times, *Gl* (gold) twice, *gros* (size) and MORS (death). Inscribed in gold over red (in a cursive hand):
William Pa[rr] / *Marquis o[f]* / *Northamp/:ton.* 317 × 211 mm. Parker 57; RL 12231.

William Parr was the son of Sir Thomas Parr of Kendal, who occupied various senior posts at court (including that of Comptroller of the Household) before his death in 1517. William was knighted in 1537 and was created Baron Parr in 1539. His sister, Catherine, who was probably one year older, became Henry VIII's sixth (and last) wife in 1543; in the same year William was appointed Privy Councillor, Knight of the Garter and Earl of Essex. Four years later he became Marquess of Northampton, the title inscribed (via Cheke) on this drawing. He was Lord Great Chamberlain to Edward VI from 1550, but was imprisoned under Queen Mary; his titles were restored by Queen Elizabeth. In 1547 he had married, as his second wife, Elizabeth, the daughter of George Brooke, Lord Cobham (no. 22).

No related painting is now known, although Vertue described a portrait of the sitter in the collection of Dr Meade. No metalpoint over-drawing can be identified in no. 24. It has been suggested that the medallion and hat badge worn by Parr were part of the uniform of the Gentlemen Pensioners, of which he was appointed Captain in November 1541–2. The earliest surviving portrait of a Gentlemen Pensioner is that ot Sir William Palmer, attributed to G. Flicke and datable *c*.1546 (*Henry VIII*, cat. no. x.2). There a large gold medallion is suspended from Palmer's neck in a similar way to that in no. 24. The Gentlemen Pensioners were a band of royal retainers who protected the king on the battlefield and at great ceremonial processions (*Henry VIII*, p.136). The Pensioners were reformed in 1539, and thereafter made their first public appearance at the reception of Anne of Cleves in 1540. It is anyway likely that the drawing dates from Holbein's last years. Among the surviving Windsor drawings, no.24 includes an unusual amount of freehand ink drawing, particularly in the details top left. Pen notations are used to indicate details of colour, material and scale, which could only have been shown in coloured chalk with a much greater expenditure of time.

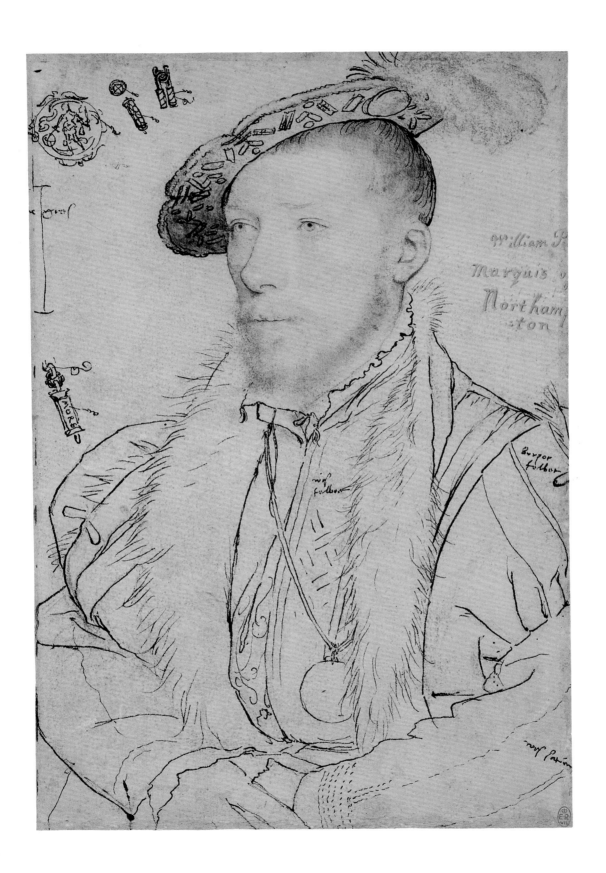

Sir Thomas Wyatt c.1504–42

c.1535

Black, white and coloured chalks, with pen and ink, on pink prepared paper.
Inscribed in gold over red: *Tho: Wiatt Knight.* 372 × 269 mm.
Parker 64; RL 12250.

Sir Thomas Wyatt was the son of Henry VIII's Treasurer from 1524 to 1548, Sir Henry Wyatt (d.1537) of Allington Castle, Kent. Thomas was educated at St John's College, Cambridge and became Clerk of the King's Jewels in 1524. In 1527 he was part of the English embassy to the Vatican and 1529–30 he served as High Marshal at Calais. He was appointed Privy Councillor in 1533 and was knighted in 1535. He was temporarily imprisoned after the execution of Anne Boleyn: he may have been her lover before she became Queen. In 1537 Wyatt repudiated his wife, Elizabeth (sister of George Brooke, Lord Cobham: no. 22), for adultery. Between 1537 and 1539, he was ambassador to Charles V. Shortly before his death he received grants of land at Lambeth and in Maidstone. His son, Thomas Wyatt the Younger (1520–54), was the instigator of the unsuccessful rebellion in 1554 against the Catholic rule of Queen Mary and Philip of Spain.

But the Elder Thomas Wyatt is better known as a poet than as a public figure. His writings (both sacred and profane) reveal the depth of his knowledge of foreign literature, particularly the writings of Petrarch and later Italians. With Surrey (no. 12), he was largely responsible for introducing the sonnet into English literature, but also wrote fine verse in the English tradition. Wyatt's death was marked by several literary outpourings, including Leland's *Nœniœ in mortem Thomœ Viati* (1542).

The poems of Wyatt and Surrey were published in *Tottel's Miscellany* (1557).

Wyatt may have been introduced to Holbein by his father who (as Treasurer of the Chamber) paid the artist for his work at Greenwich in 1527. Holbein's portrait of Sir Henry (Rowlands 29) may date from that time, or soon after 1532. (See E. Foucart-Walter, *Les Peintures de Holbein le Jeune au Louvre*, Paris, 1985, pp.50 and 68, in which a date *c.*1535 is suggested.) Thomas Wyatt the Elder must have sat to Holbein at least twice: once for the present drawing (and Parker 65), and once – probably a few years later – for the bareheaded image, in three-quarters profile to the right, reproduced in a roundel as a woodcut to accompany Leland's elegy. Various derivations of the latter type are known, one of which may have been the portrait of Wyatt by Holbein included in the 1655 inventory of Arundel's collection (Strong, pp.338–9). Thomas Wyatt the Younger may also have sat to Holbein, *c.*1540 (Strong, pp.340–1).

There is a second, almost identical, drawing of Wyatt among the Holbein series at Windsor (Parker 65). The two are clearly interdependent. On balance, it appears that no.25 is the prime original, and Parker 65 the copy, although no reason for the copy has been suggested: it is most unlikely to have been made by Federico Zuccaro, as Parker tentatively suggested. Neither study appears to include over-drawing.

Anonymous sixteenth-century artist after Holbein *Sir Thomas Wyatt*
(woodcut, from Leland's *Nœniœ in mortem Thomœ Viati*, 1542; London, British Library).

Tho: Wiatt Knight.

William FitzWilliam, 1st Earl of Southampton c.1490–1542
c.1536–40

Black, white and coloured chalks, with metalpoint over-drawing, on pink prepared paper.
Inscribed in gold over red: *FitzWilliams Earl of Southampton*.
383 × 270 mm. Watermark: two-handled vase with double flower cresting (Briquet 12863).
Parker 66; RL 12206.

William Fitzwilliam, the son of Sir Thomas Fitzwilliam, was a childhood friend and contemporary of Henry VIII. He was appointed Gentleman Usher in 1509, and fought in France in 1512 and 1513; in the latter year he was knighted. While serving as Ambassador to France in 1521 he had his portrait taken, but complained that the artist 'did not do my portrait well … he made [it] in haste' (Foister, p.3). In the following year he became Vice-Admiral. He served as Treasurer of the Household 1525–37. Fitzwilliam became a member of the Order of the Garter in 1526, and four years later Chancellor of the Duchy of Lancaster. His most important appointment was Lord High Admiral (1536–40), in which role he was in charge of England's navy; he also, in 1539, organised the reception of Anne of Cleves at Calais. Between 1540 and his death two years later he was Lord Privy Seal (following Thomas Cromwell). He was created Earl of Southampton in 1537. On his death the Earldom became extinct. It was recreated in 1547 for Thomas Wriothesley, the subject of Holbein's portrait drawing in the Louvre.

This drawing is closely associated with the full-length portrait of Fitzwilliam, not by Holbein, at Cambridge (Rowlands R.32). The painting shows him holding the staff of Lord High Admiral and the collar of the Garter, both of which are summarily indicated in the drawing. The Cambridge portrait (which is perplexingly inscribed 1542) includes water and shipping behind, a clear allusion to the sitter's role between 1536 and 1540, which must be the terminal dates for the drawing.

The contours of no. 26 have all been over-drawn with metalpoint, a probable indication of its use, during Holbein's lifetime, in the preparatory stages of an oil painting. Holbein's original painting may have been destroyed in the fire at Cowdray House (Fitzwilliam's home from 1529) in 1793. Two portraits of Fitzwilliam were noted in the 1655 Arundel inventory: 'ritratto de ffitzwilliams Conte di Southampton' and 'Conte de Southampton Fitzwilliams'. Both were listed as works of Holbein (Cust, pp.283 and 323).

Anonymous artist after Holbein *William Fitzwilliam, 1st Earl of Southampton*
(oil on panel, 187.1 × 100 cm; Cambridge, Fitzwilliam Museum; Rowlands R.32).

Fitz Williams Earl of Southampton.

27

Mary Zouch

c.1533–6

Black and coloured chalks and black ink, on pink prepared paper.
Annotated by the artist: *black felbet* (black velvet). Inscribed in gold over red: *M Souch*.
294 × 201 mm. Watermark: lion holding orb and shield (Arms of Zurich; Briquet 878).
Parker 72; RL 12252.

The inscription ('M Souch') may indicate a lady with a Christian name commencing with M, or merely 'Mistress Souch'. If the former, she may be Mary, the daughter of John, Lord Zouch of Haringworth. In 1527 she wrote to her cousin, Lord Arundel, asking to be taken into royal service as her stepmother was cruel to her. Mary may then be the 'Mrs Souche' who attended Jane Seymour and received an annuity for her services in 1542.

If 'Mistress Souch', the sitter could be any female member of the Zouch of Haringworth family, or – more probably – Anne Gainsford, lady-in-waiting to Anne Boleyn, who later married George Zouche of Codnor (see *Henry VIII*, p.101).

No related painting is known. There appears to be no metalpoint over-drawing, but some contours – particularly in the lower part of the sheet – seem to have been reinforced with black chalk. Stylistically the drawing would appear to date from early in Holbein's second English period.

The large medallion lightly indicated below the centre of the neckline was described by Chamberlain as a representation of Perseus and Andromeda. Large medallions are worn by a number of Holbein's sitters, both male (as hat badges) and female (as brooches). The plain and apparently unjewelled medallion shown here is paralleled by the large circular medallion on the painted portrait of Lady Rich in New York (Rowlands R.26).

M Souch.

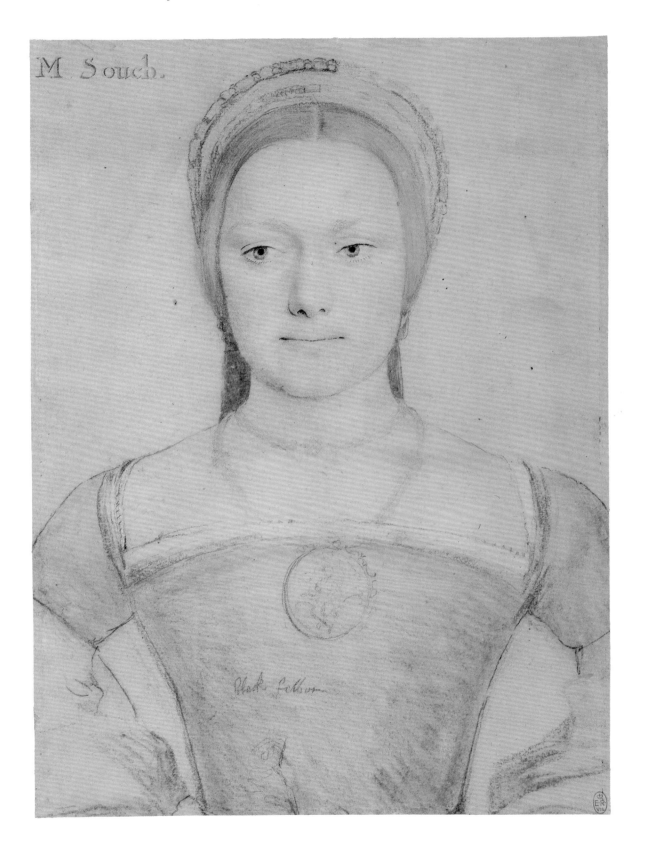

✎ 28 ✎

Grace, Lady Parker born c.1515
c.1533–6

Black and coloured chalks on pink prepared paper.
Inscribed in gold over red: *The Lady Parker.*
298 × 208 mm. Parker 73; RL 12230.

The sitter in this drawing is probably identifiable as Grace, daughter of Sir John Newport, who married Henry Parker, son and heir presumptive to 10th Baron Morley, in 1523, when she was eight years old. The Parkers had two sons (*c.*1532 and 1537) and Lady Parker was present both at the christening of Prince Edward and the funeral of Jane Seymour in 1537. Henry Parker was Sheriff of Hertfordshire in 1536. His remarriage before 1549 indicates that Grace was already deceased. He died in 1553, three years before his father.

This drawing is very similar in status to no. 27 and it is likely that both sitters were portrayed as attendants to Queen Jane Seymour. No related painting is known.

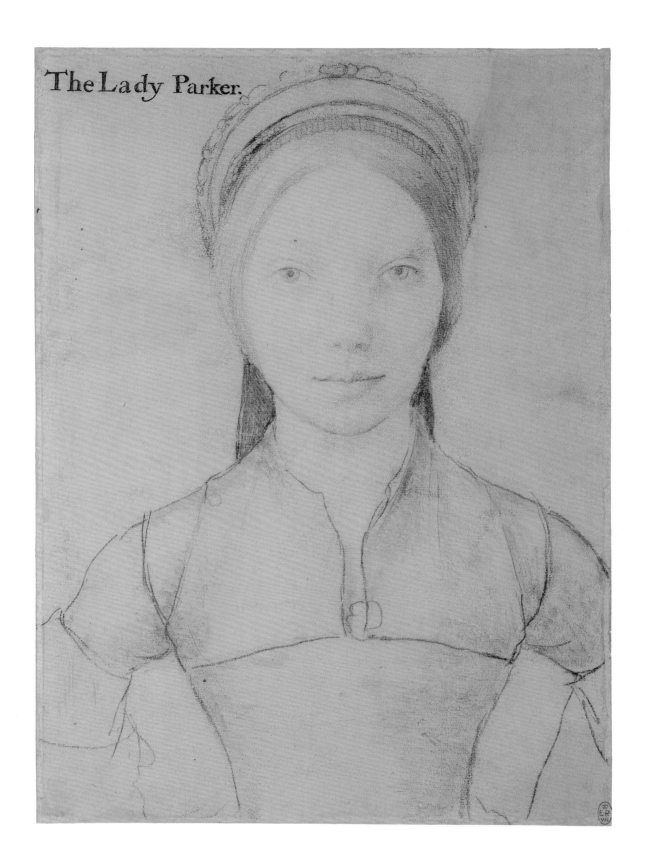

The Lady Parker.

THE MINIATURES

THE FIVE MINIATURES BY HOLBEIN IN THE ROYAL COLLECTION – all of which are included in this exhibition – represent one-third of the artist's surviving work in this medium. The fact that the earliest of these (no. 29) is a figurative work serves to remind us that the origins of miniature painting lie in the work of manuscript illuminators. The media (watercolour and bodycolour on vellum) are indeed precisely those employed by illuminators. The main distinguishing features are the stiff card backing and frame or case, provided to support and enhance the miniature portrait as an independent work of art.

According to Karel van Mander, writing over fifty years after the artist's death, Holbein was taught the art of illumination by 'Master Lucas', who is probably identifiable with Lucas Horenbout (c.1490/5–1544), the Flemish miniaturist employed by Henry VIII from 1525. But Holbein may have been at least as impressed by the work of Jean Clouet for the French court. Clouet's first miniature portraits are the roundels, contained within a broad gold-painted border, that were incorporated into a manuscript entitled 'Les Commentaires de la Guerre Gallique'. In addition to François I himself, six of the French King's generals – the *Preux de Marignan* – were portrayed by Clouet for this manuscript (Mellen 126–33). Full-scale preparatory drawings survive at Chantilly for five of the six *Preux* (Mellen 1–5). The earliest surviving independent miniature by Clouet may be that of the Dauphin François in the Royal Collection (illustrated opposite; Mellen 135), of c.1525–8. In 1526 Madame d'Alençon, sister of François I, sent Henry VIII elaborately framed miniature portraits of the French King and his two sons (including the Dauphin). The miniature of the Dauphin François appears to have been acquired only in the late nineteenth century, but presumably records the approximate likeness of the miniature in the 1526 gift.

The first miniature portraits of Henry VIII (by Horenbout) date from precisely the time of the arrival of the French gift, and they are very much in the French tradition. Holbein's earliest datable works in miniature were painted just under ten years later. Solomon (no. 29) is datable c.1534. What appears to be Holbein's first surviving portrait miniature, that of Lord Abergavenny (Rowlands M.2), was probably painted shortly before the sitter's death in June 1535. While no. 30 may have been made at the time of Lady Audley's marriage in 1538, no. 31 is probably around two years later and nos. 32 and 33 are dated 1541. None of these works is signed: their association with Holbein is based on their innate quality, their relationship with securely attributed preparatory drawings (as for no. 30), comparison with other known works by the artist (as for no. 29), and traditional attributions (as for nos. 32 and 33). Technical analysis and microscopic examination reveals that Holbein's miniature style was quite distinct from that of both his master, Horenbout, and his follower, Nicholas Hilliard (1547–1617). In contrast

to their treatment, Holbein modelled the interior forms with a delicate yet firm series of strokes, which become deeper (or more intense) to indicate the changing contours. Not surprisingly, this technique was in many ways the same as his chalk drawing technique, in miniature. According to Van Mander, Holbein 'as far excelled Lucas in drawing, arrangement, understanding, and execution, as the sun surpasses the moon in brightness'. The statement of Holbein's own follower, Hilliard, records a more practical indebtedness: 'Holbean's maner of limning I have ever imitated and howld it for the best'.

As with the Windsor drawings, the miniatures have a complex (and often undocumented) history. Solomon (no. 29) was probably a gift from Holbein to the King, but it had left the Royal Collection by 1642, when it is recorded in Arundel's collection. By 1688 it was in James II's collection at Hampton Court, but was noted by Vertue (in 1743) in the Queen's Closet at Kensington. Although the Brandon boys (nos. 32 and 33) were close friends of Edward VI, their miniature portraits did not enter the Royal Collection until the reign of Charles I, to whom they were presented by Sir Henry Fanshawe. Meanwhile the portraits of the two ladies (nos. 30 and 31) were probably only acquired in the reign of Queen Victoria. Unfortunately none of these miniatures has survived in its original frame. The sixteenth-century settings would have emphasised still further the very precious and personal nature of these miniature masterpieces.

In view of the extensive patronage given to Holbein by Henry VIII, it is curious that no miniature portrait of the King by Holbein has survived. However, the figure of Solomon in no. 29 is surely intended as a personification of the King.

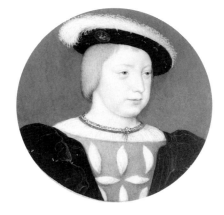

Jean Clouet *François, Dauphin of France*
(miniature on vellum, diam. 62 mm; Royal Collection; Mellen 135).

➤ 29 ➤

Solomon and the Queen of Sheba

c.1534

Watercolour, bodycolour (including gold) and metalpoint on vellum laid on to card.

Inscribed, in the foreground: REGINA SABA (the Queen of Sheba). On either side of the throne: BEATI VIRI TVI … ET BEATI SERVI HI TVI / QVI ASSISTVNT CORAM TE … OMNITPE ET AVDIVNT / SAPIENTIAM … TVAM; on the curtain behind Solomon: SIT DOMINVS DEVS TVVS BENEDICTVS, / CVI COMPLACIT IN TE, VT PONERET TE / SVPER THRONVM SVVM, VT ESSES REX / (CONSTITVTVS) DOMINO DEO TVO.

(Happy are thy men and happy are these thy servants, who stand in thy presence, and hear thy wisdom. Blessed be the Lord thy God, who delighted in thee, to set thee upon his thorne, to be King elected by the Lord thy God).

And on the steps of the throne: VICISTI FAMAM / VIRTVTIBVS TVIS *(By your virtues you have exceeded your reputation).*

228 × 181 mm. Parker frontispiece; Rowlands M.1; RL 12188.

This exquisite miniature is unique in Holbein's œuvre, and clearly indicates the debt owed by his own portrait miniatures (e.g. nos.30–33) to the tradition of manuscript illumination.

The texts incorporated in the composition refer to Solomon's meeting with the Queen of Sheba, and are based on II Chronicles 9 (verses 7–8). The central figure of Solomon is clearly a portrait likeness of Henry VIII. His position and seated pose imitates official depictions of the King in Majesty, such as that on the initial letter of the Treaty of Windsor (1532) attributed to Horenbout (see *Henry VIII*, p.86), or at the foot of the title-page (designed by Holbein himself) of Coverdale's Bible (1535).

Solomon (i.e. Henry VIII) is here shown receiving the homage of the Queen of Sheba (the traditional personification of the Church). By receiving her homage, the King receives the homage of (and implicit acceptance by) the Church of England. The text further implies that the King is answerable only to God. The miniature must therefore date from around the time of Henry VIII's assumption of the role of Supreme Head of the English Church in 1534. It incorporates the only autograph likeness of Henry VIII by Holbein in the Royal Collection, and possibly his first surviving portrait of the King.

No. 24 was part of the extraordinary collection of works by Holbein assembled by the Earl of Arundel in the early seventeenth century and is listed in the 1655 Arundel inventory. It is shown, in a circular frame, in Cornelis Schut's *Allegory on the Death of the Earl of Arundel*, etched by Hollar in 1646 (Parthey 466). It was still in a circular frame a hundred years later, when it hung in the Queen's Closet at Kensington (see p.21). Although it is likely that it was presented to Henry VIII (in a circular frame) soon after its completion, there is no record of its presence in the Royal Collection until 1688 when it was hanging at Hampton Court. John Rowlands has suggested either Thomas Cromwell or Richard Rich as possible donors: 'Henry was compared … in an orgy of flattery, with Solomon for his justice and prudence in [Rich's] speech on election as Speaker for the parliament that met on 8 June 1536' (Rowlands, p.93). A further piece of flattery may have been included in a passage from the Wisdom of Solomon 6 (verse 24), introduced in Hollar's etching (Parthey 74) and probably transcribed by him from the frame: 'But the multitude of the wise is the welfare of the world: and a wise king is the upholding of the people'.

far left
Decorated initial in *The Treaty of Windsor*, 1532 (ink and wash on vellum; Paris, CARAN, Archives Nationales, AE III 31).

left
Hans Holbein the Younger, detail from title page of *The Coverdale Bible*, 1535 (woodcut; London, British Library).

⁓ 30 ⁓

Elizabeth, Lady Audley
c.1538

Watercolour and bodycolour on vellum laid on to a playing card.
Circular, diam. 57 mm.
Rowlands M.9.

There are two possible candidates for identification as the subject of this miniature and of the related drawing inscribed 'The Lady Audley': Elizabeth Tuke, wife of 9th Baron Audley (who succeeded in 1557), and Lady Elizabeth Grey (died before 20th November 1564), wife (from 1538) of Thomas, Lord Audley of Walden (died 1544), Lord Chancellor from 1532. On balance, the second seems the more likely. Roy Strong's suggestion that the portrait may have been made at the time of Lady Audley's marriage is appealing.

In Holbein's surviving work there are only three miniature portraits for which related full-scale drawings have survived. In none of these cases was the drawing worked up into a full-size painting. It is sometimes forgotten that the portrait of Anne of Cleves in the Louvre is actually a worked-up drawing, on vellum, backed on panel. The related miniature is in the Victoria & Albert

Museum. The drawing of Lord Abergavenny (Pembroke Collection, Wilton House), which was used for the miniature now in the Buccleuch collection, was probably once part of the Windsor series, but became separated from it in the early seventeenth century. The drawing of Lady Audley is still in the Royal Collection (Parker 58), but was not included in the present selection. The sitter's facial features are there recorded, and details of her jewels (which vary somewhat from those in the miniature) and dress are noted.

The first certain reference to no. 30 appears to occur in Woltmann's monograph, published in 1866, by which time the miniature was part of the Royal Collection. It is possible, however, that the 'Dutch woman in a red garment holding both her hands together. In small Limbning', noted in royal inventories from the late 1660s, is identifiable with this miniature.

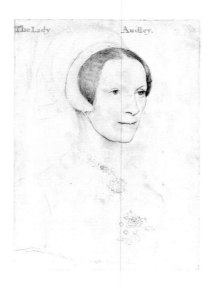

Hans Holbein the Younger *Elizabeth Lady Audley*
(black and coloured chalks, with metalpoint and pen and ink, on pink prepared paper, 293 × 208 mm;
Windsor Castle, Royal Library; Parker 58).

[88]

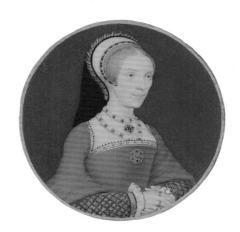

? Queen Catherine Howard

C.1540

Watercolour and bodycolour (including gold and silver) on vellum laid on to a playing card.
Circular, diam. 64 mm.
Rowlands M.8.

The sitter in this portrait, and in the slightly reduced autograph replica in the collection of the Duke of Buccleuch (Rowlands M.7), cannot be identified positively on the basis of contemporary inscriptions, for none exist. Her rich costume (including a bodice of cloth of gold and a fur of stole) and the jewels set into the neckline and headdress, and incorporated into the necklace, would seem to suggest a sitter of considerable standing. The miniatures must date from within the relatively short period of Holbein's activity as a miniaturist between *c.*1534 and his death in 1543. These factors would seem to support the identification of the lady as Queen Catherine Howard, first made for the Buccleuch version *c.*1735 and for the Windsor version in 1844.

Catherine Howard (born 1520–1) was the niece of Thomas Howard, Duke of Nofolk. In July 1540, the same month as Anne of Cleves was divorced, she became Henry VIII's fifth wife. Late in the following year she was charged with adultery and in February 1542 she was beheaded.

Recent studies have concentrated on the jewels worn by this sitter. The large pendant (a ruby above an emerald) hanging from the neck is precisely that shown by Holbein in his portrait of Jane Seymour of 1536 (see no.21), and would have formed part of the royal jewel collection. The jewelled neckline could be related to the 'Square conteignyng xxxiij Diamondes and lx rubyes with an Edge of peerll conteignyng xxiij', presented to Catherine Howard by Henry VIII in 1540 (*Princely Magnificence*, exhibition catalogue, London, 1980, p.5). If this miniature represents Queen Catherine, it is likely that it was painted soon after her receipt of this gift. Although several of the Windsor drawings have been associated with the lady shown in this miniature (Parker 60 and 62), none is close enough to be of direct relevance.

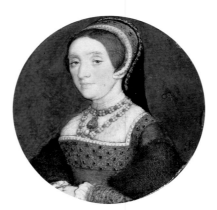

Hans Holbein the Younger *?Queen Catherine Howard*
(miniature on vellum, diam. 51 mm; Collection of the Duke of Buccleuch & Queensberry, KT; Rowlands M.7).

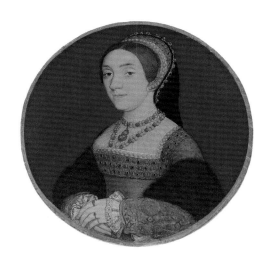

Henry Brandon, 2nd Duke of Suffolk 1535–51

1541

Watercolour and bodycolour on vellum laid on to a playing card.
Inscribed in black ink: ETATIS.SVÆ. 5. 6. SEPDEM./ANNO/1535.
Circular, diam. 57 mm.
Rowlands M.10.

Charles Brandon, 3rd Duke of Suffolk 1537/8–51

1541

Watercolour and bodycolour on vellum laid on to a playing card.
Inscribed in black ink: ANN/1541/ETATIS.SVÆ. 3./. 10. MARCI
Circular, diam. 57 mm.
Rowlands M.11.

The boys shown in nos. 32 and 33 were brothers, sons of Charles Brandon, 1st Duke of Suffolk (d.1545) and his fourth wife, Catherine Willoughby. The Brandon family had close links with the royal court. The year after the elder Charles had been raised to a dukedom (1514), he secretly married the King's sister, Mary. The 1st Duke's elder son, Henry (no. 32), was educated with Prince Edward and carried the Orb at his Coronation in 1547. He was considered to have great promise, and was strong and courageous, while his younger brother, Charles (no. 33) was 'not robust'. Immediately after the Coronation both brothers were made Knights of the Bath. They were renowned for their learning and studied at St John's College, Cambridge. The brothers died of the sweating sickness in 1551, within an hour of each other. Henry had succeeded as 2nd Duke of Norfolk in 1545. He was himself succeeded – for an hour – by Charles as 3rd Duke. In 1551 Thomas Wilson, formerly tutor to the Brandon boys, produced a biography with several epitaphs to the much lamented boys.

Nos. 32 and 33 were presumably commissioned by the boy's father, 1st Duke of Suffolk, of whom a sub-Holbein image, c.1540–5, is known (Rowlands R.30). According to Van der Doort, the two miniatures were given to Charles I – presumably while Prince of Wales – by Sir Henry Fanshawe (1569–1616), Remembrancer of the Exchequer from 1601.

While the inscription on no. 32 appears to record the sitter's age (5 years) at the time of painting, and his date of birth (1535), that on no. 33 records both his age (3 years) and the date of the actual painting (10 March 1541). The significance of the date (6 September) on no. 32 is unclear: Henry Brandon was born on 18th September. Although not strictly speaking a pair – the gold border is marginally narrower in no. 33, and the poses are not complementary – the miniatures were probably painted at around the same time. When in Charles I's collection, one of the Brandon miniatures was kept in 'a round double turnd ivorie Box without anie Christalls'.

The poses are miniature versions of those employed by Holbein for large-scale portraits of adults. While no. 32 is reminiscent (in reverse) of Derich Born (Rowlands 44), no. 33 is close to the exactly contemporary portrait of Edward, Prince of Wales (Rowlands 70). However, instead of the right hand raised in princely blessing, Charles Brandon's hands rest on an inscribed sheet, testimony of the three-year-old sitter's precocious ability. Technical examination carried out in 1977 disclosed that the hands of both no. 32 and no. 33 had been corrected by the artist.

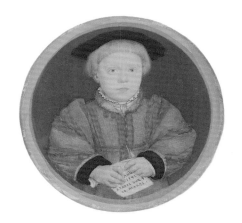

33

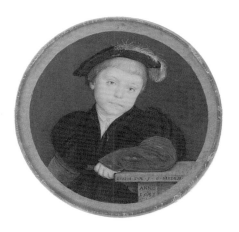

32

Bibliography

The standard work on Holbein's drawings at Windsor is still Parker's 1945 catalogue (reprinted, with an appendix by Susan Foister, in 1983). All the drawings catalogued by Parker were also published in the 1983 facsimile edition (see Foister). The Holbein miniatures (and drawings) were included in the exhibition entitled *Holbein and the Court of Henry VIII* at The Queen's Gallery, London, 1978–79. Graham Reynolds's catalogue of the Tudor and Stuart miniatures in the Royal Collection (including those by Holbein) is forthcoming. For a recent discussion of Holbein's complete painted *œuvre*, see Rowlands. The only full survey of Holbein's drawings is that by Ganz. Biographical details are discussed, *in extenso*, in A. Chamberlain, *Hans Holbein the Younger* (London, 1913).

In the foregoing text the following works have been referred to in abbreviated form:

Ainsworth — M. Ainsworth, '"Paternes for phisioneamyes": Holbein's portraiture reconsidered', *Burlington Magazine*, CXXXII, 1990, pp.173–86

Briquet — C. M. Briquet, *Les Filigranes* (Paris, 1907; reprinted Amsterdam, 1968)

Cust — L. Cust, 'Notes on the Collections formed by Thomas Howard, Earl of Arundel and Surrey', *Burlington Magazine*, XIX, 1911, pp.278–87 and 323–5

Foister — S. Foister, *Drawings by Holbein from the Royal Library, Windsor Castle* (London and New York, 1983)

Ganz — P. Ganz, *Les Dessins de Hans Holbein le jeune* (Geneva, 1939)

Henry VIII — *Henry VIII. A European Court in England* (exhibition catalogue, ed. D. Starkey), National Maritime Museum, Greenwich, London, 1991

Mellen — P. Mellen, *Jean Clouet* (London, 1971)

Millar — O. Millar, *The Tudor, Stuart and Early Georgian Pictures in the Collection of Her Majesty The Queen* (London, 1963)

Parker — K. T. Parker, *The Drawings of Hans Holbein in the Collection of His Majesty The King at Windsor Castle* (Oxford and London, 1945); reprinted, with an Appendix by Susan Foister (London and New York, 1983)

Parthey — G. Parthey, *Wenzel Hollar* (Berlin, 1853), expanded by R. Pennington, *A Descriptive Catalogue of the Etched Work of Wenceslaus Hollar* (Cambridge, 1982)

Rowlands — J. Rowlands, *Holbein: the Paintings of Hans Holbein the Younger, Complete Edition* (Oxford, 1985)

Strong — R. Strong, *National Portrait Gallery. Tudor and Jacobean Portraits*, 2 vols. (London, 1969)

Tudor Court — *Artists of the Tudor Court* (exhibition catalogue by R. Strong), Victoria & Albert Museum, London, 1983

Index of Sitters